LETTERING WORKBOOKS

applied lettering

GEORGE EVANS · CHRISTINE CASH

STUDIO
VISTA

Studio Vista
© Diagram Visual Information Ltd 1988

First published in Great Britain in 1989
by Studio Vista
an imprint of Cassell Publishers Limited
Artillery House, Artillery Row
London SW1P 1RT

British Library Cataloguing in Publication Data
Evans, George and Cash, Christine
 Applied lettering.–(Lettering workbooks)
 1. Lettering
 I. Title II. Series
 745.6'1

ISBN 0–289–80014–5

The Diagram Group

Designer	Bruce Robertson
Editor	Sylvia Worth
American consultant	Marian Appellof
Art staff	Elizabeth Benn, James Dallas,
	Brian Hewson, Lee Lawrence,
	Paul McCauley, Philip Patenall
	Jane Robertson, Graham Rosewarne,
	Katherine Rubidge

Printed and bound by Snoeck Ducaju & Sons,
Ghent, Belgium

Lettering Workbooks

THIS BOOK IS WRITTEN TO BE USED.
It is not meant to be simply read and enjoyed. Like a course in physical exercises, or any area of study, you must carry out the tasks to gain benefit from the instruction.

1 Read the book through once.
2 Begin again, reading two pages at a time and carry out the tasks set before you go on to the next two pages.
3 Review each chapter by re-examining your previous results and carrying out the review tasks.
4 Collect all your work and store it in a safe place, having written in pencil the date when you did the work.

LEARNING HOW TO DO THE TASKS IS NOT THE OBJECT OF THE BOOK. It is to learn lettering and calligraphy by practicing the tasks. Do not rush them.

LETTERING WORKBOOKS ARE:
1 A program of clear instruction.
2 A practical account of various techniques and procedures.

Like a language course, the success of your efforts depends upon you.
YOU DO THE WORK!

Contents

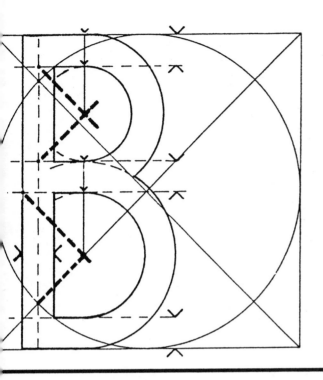

Topic finder

Introduction

Letterforms are an important part of our lives. They direct, inform, persuade and give us pleasure. Whether consciously or subconsciously we are drawn towards the "silent persuader." Many thousands of lettering styles in their differing shapes and guises, produced by various methods and in a myriad of materials, are continually beckoning us to read.

"*Applied Lettering*" has been written for those with little or no previous knowledge of the proportion and construction of letterforms. The step by step instructions given will introduce the reader to the world of lettering from basic alphabet construction through to finished projects.

Materials, tools and surfaces, and a good working area, are an important foundation, but enthusiasm and patience are also vital ingredients if the subject of creating letterforms is to be mastered.

Different alphabet styles and a letter's constituent parts are discussed in this book. After studying the topics of letter and word spacing, which are as important as the letterforms themselves, the student will begin quite naturally to question whether or not adequate space has been used in the design of a word or phrase. Suddenly, that which was once accepted and taken for granted becomes an issue.

The first Sans serif alphabet in this book is relatively easy to construct and has been included to dispel any doubts students may have about their ability to create letterforms.

Next the student is guided through the production of a free hand Roman alphabet. This will train both hand and eye as the student learns to draw the form that he or she sees, rather than what he thinks he sees.

Having gained a command of creating Roman alphabet freehand the student should then be ready to try the brush script. Detailed practical guidance on the techniques used in creating brushstrokes to produce letterforms is given.

Information on embellishing alphabets is included for those who are adventurous and wish to add that "extra touch" to their work. The final chapter also includes ideas and practical advice on how to apply letterforms in project work such as stencil making and painted signs.

Lettering and its application open up an entirely new world and understanding of the forms that surround us. After having worked through the book the reader should be more aware of the subtleties that exist in lettering and of the potential that exists within this subject area.

Chapter 1

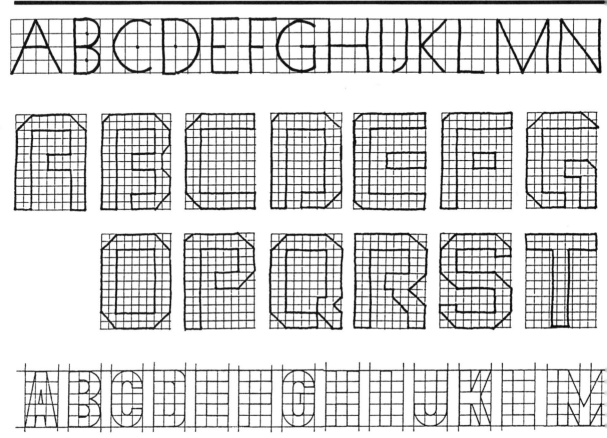

MATERIALS AND TOOLS

The words "applied lettering" cover a number of processes and methods adopted to put letterforms to good use. The subject is wide and requires patience and understanding if all the disciplines are to be mastered. Many instruments are used, with letters being created by pen, brush and scalpel and each tool requiring a different technique.

The eyes and hand are the only common denominator and they require training in order to achieve a satisfactory result. Learning how to produce letterforms that are dignified, well spaced and informative is an art which requires practice and dedication.

This chapter is about the work area, tools and equipment which you will require. A good, clean working attitude is an attribute – clean work surfaces, materials and equipment are essential, sharp pencil points on compasses a necessity.

On the following pages the tools, surfaces and mediums used in producing letterforms are illustrated. It is not necessary to buy all the equipment before you begin, only that which is required for each section as you progress through the book.

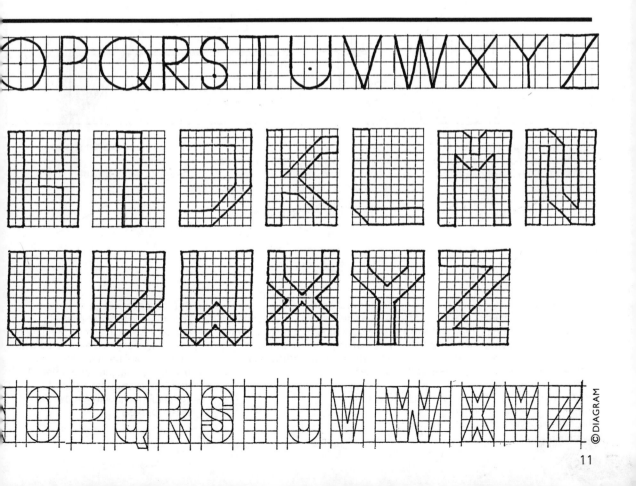

Your work area

You will need a comfortable area in which to work. Good environmental conditions such as adequate lighting and space play an important part in helping you to produce work of a high quality. Lighting, wherever possible, should be natural and, for a right handed person, directed from the left, with the reverse being true for a left handed person. Make sure that you have plenty of shelving and flat storage space for copy, briefs or samples and your instruments, tools, inks and other necessary equipment.

The most important piece of equipment is a sloped drawing board, preferably with an adjustable parallel motion, although this is not essential. A fixed sloped position board and tee square will produce equally good results but a little more slowly.

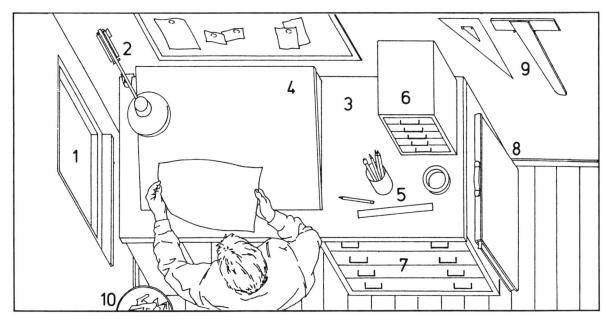

1 Natural daylight. Note that the work area is positioned so as to maximize the use of natural light.
2 Desk lamp.
3 Sturdy flat surface (desk top or table) on which to rest your drawing board.
4 Drawing board.
5 Space in which to keep your pens, pencils, ruler, eraser, and tape.
6 Stationery cabinet.
7 Drawer space.
8 Portfolio for keeping samples of your work.
9 Tee square and set square (triangle).
10 Waste paper basket.

Cutting area
You will need a flat work space on which to place a cutting mat. This can be simply a heavy strawboard or a self healing cutting board. The area allotted for trimming should be larger than the mat to give room for maneuvering large sheets. Your trimming knife and straight edge should be conveniently positioned within this area.

Material storage
A plan chest is useful for storing the papers and boards used in lettering. Alternatively a shelving system constructed from particle board may be used.

Equipment storage
A storage unit, preferably with drawers, is essential for storing tools and equipment. A drawer lined with thin foam will prevent tools from becoming scratched or blunted. A useful storage unit is a plastic vegetable rack, with removable plastic baskets.

Home made drawing board
This illustration shows a home made drawing board. It is adjustable to three positions and packs flat for storage. When using this type of board you will need a tee square for projecting horizontal lines.

Portable parallel motion drawing board
The portable drawing board is the most versatile as it can be used on a desk and then folded away to leave a useable desk top area.

Parallel motion drawing board
The motion allows horizontal lines to be drawn leaving the non-writing hand free. This type of board is available in desk top form or free standing on a fold-away frame. The desk top board is a permanent fixture usually bolted to a desk or work station. The free standing variety requires floor space and can stand next to a desk area, leaving a work surface available for use other than with a drawing board.

Task
Choosing your drawing board
Visit your art suppliers and look at the various boards available. With your work area in mind, and available storage space, decide on the type that will be best for you.

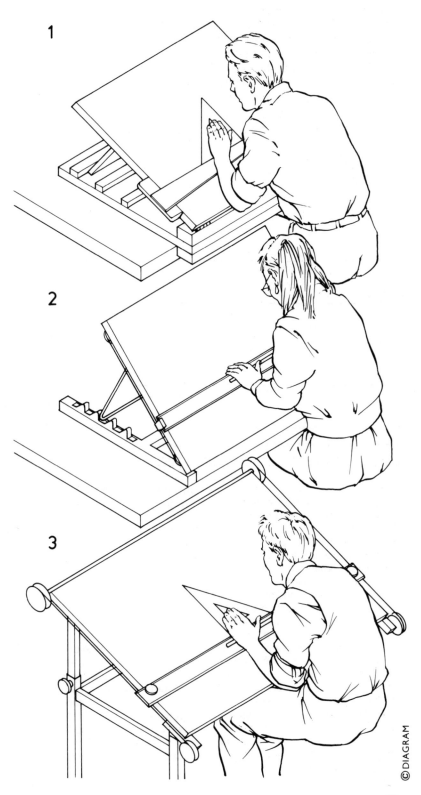

© DIAGRAM

Surfaces

The art market is flooded with a myriad of materials which can be used for writing or lettering surfaces. These range from papers through to laminate finished particle board, and from aluminum to stone finishes. A wide variety of mediums are used in lettering.

Surfaces
The surface chosen for a piece of work is usually determined by the envisaged lifespan of the finished product and its location.

In general, surfaces can be divided into the following groups:
1 Layout papers and bleedproof papers used for mapping out ideas and finished letterforms before tracing down.
2 Stiff papers and board used for indoor, short life (ephemeral) work.
3 MG (machine glazed) papers used for posters and notices where a certain amount of weathering occurs but the work is semi-permanent.
4 Art board and papers having a highly finished surface, used for producing artwork.
5 Painted woods, laminates, metals etc, used for permanent signs where weather proofing is essential.

Layout papers
There are two main types of layout paper; the first of these is ordinary layout paper, which is used for water based pens, and the second is bleedproof paper, which is used for spirit based pens.
Semi-translucent (such as greaseproof) tracing and ordinary layout papers are ideal for mapping out letterforms prior to tracing down the image onto the finished surface. They are suitable for pen, pencil and fiber (felt-tip) pen work, but because of instability do not accept brushed ink or paint readily without forming buckles. Ordinary layout paper is available in pads, sheets and rolls. Bleedproof paper is impregnated to allow the use of marker pens without the color merging. It is available in pads.

Stiff papers and board
Opaque paper, available in various weights and colors, is ideal for producing finished signs, posters and handbills for internal use. The surfaces vary from smooth, for fine detail work, to rough. It takes pencil, fiber and felt pens, both water and spirit based, but some markers bleed on this surface. It is available in pads, sheets and rolls.

Machine glazed (MG) poster paper
An opaque paper with a smooth writing surface that accepts waterproof inks and acrylic paints. The reverse side of the paper has a roughened finish for glue application when pasting bill posters. It is available in various colors including fluorescent, in sheets and rolls.

Art board and papers
These have an extremely smooth, white surface and are used for original artwork executed in black ink to be photographed for a printing process. Boards are available in sheets and the paper is available in pads and sheets.

Permanent surfaces
This group includes many materials which can be used for signs of a permanent nature. The materials include: exterior plywood (painted surface), laminates, plastics, styrenes, metals, plaster and stone finishes. The surface dictates the method of production used.

Types of work / Mediums / Surfaces

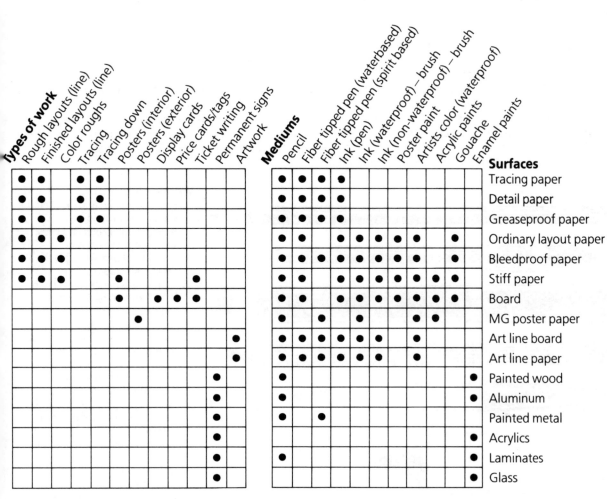

Types of work

Surface	Rough layouts (line)	Finished layouts (line)	Color roughs	Tracing	Tracing down	Posters (interior)	Posters (exterior)	Display cards	Price cards/tags	Ticket writing	Permanent signs	Artwork
Tracing paper	●	●		●	●							
Detail paper	●	●		●	●							
Greaseproof paper	●	●		●	●							
Ordinary layout paper	●	●	●									
Bleedproof paper	●	●	●									
Stiff paper	●	●	●					●	●			
Board						●		●	●	●		
MG poster paper						●						
Art line board												●
Art line paper												●
Painted wood											●	
Aluminum											●	
Painted metal											●	
Acrylics											●	
Laminates											●	
Glass											●	

Mediums

Surface	Pencil	Fiber tipped pen (waterbased)	Fiber tipped pen (spirit based)	Ink (pen)	Ink (waterproof) – brush	Ink (non-waterproof) – brush	Poster paint	Artists color (waterproof)	Acrylic paints	Gouache	Enamel paints
Tracing paper	●	●	●	●							
Detail paper	●	●	●	●							
Greaseproof paper	●	●	●	●							
Ordinary layout paper	●	●		●	●	●	●	●		●	
Bleedproof paper	●	●	●	●	●	●	●	●		●	
Stiff paper	●	●	●	●	●	●	●	●	●	●	
Board	●	●	●	●	●	●	●	●	●	●	
MG poster paper	●	●		●			●	●			
Art line board	●	●	●	●	●	●		●			
Art line paper	●	●	●	●	●	●		●			
Painted wood	●										●
Aluminum	●										●
Painted metal	●		●								●
Acrylics									●		
Laminates	●								●		
Glass											●

Mediums

The medium used in lettering varies with both the application method and the nature of the work. For internal posters which require no protection against the elements, poster paints, gouache, inks, fiber pens and brush pens are used. Where a more permanent sign is required, acrylic paints or enamels are used. Another medium used is self-adhesive film, where letterforms are cut out and applied to the board surface.

For external signs a number of methods are used, with the choice being dependent upon the surface to be decorated. Painted wooden signs may be lettered with enamel paint. Laminate signs may have acrylic letters affixed or the forms may be sprayed using an acrylic paint; wooden letters may be gilded or painted and affixed. Posters for use outdoors can be lettered in acrylic paints or waterproof inks, which weather reasonably well.

Cleaner

All liquid mediums require the appropriate thinner (reducer) and cleaner. For oil based paints, white spirit or turpentine substitute can be used. For acrylic paints and inks a suitable cleaning medium should be purchased to keep brushes and implements in good condition.

Task
Notebook
Buy a pocket size notebook for gathering information on materials that you may wish to use.

Task
Suppliers
Visit your art shop and wood and plastic laminate suppliers and make notes on the papers, boards, laminates and sheet timbers available. Pay special attention to their waterproof and weathering properties.

Task
Mediums
Investigate the paint and ink available at your local shops. Write in your notebook the brand names and types. Examine the tin, tube or bottle labels to ascertain the thinning or cleaning agent each requires and add to your list.

©DIAGRAM

Lettering tools

The writing tools and implements which will be needed in the construction of the alphabets are illustrated below.

The choice of equipment at any art material outlet is vast. When choosing your materials, always ask the assistant to show you a number of different makes of an item before making a choice. Generally the higher the price the more robust or accurate the item; however, this is not always the case and some products at the cheaper end of the market are quite adequate.

It is essential that all equipment be kept clean and pencil leads and blades sharp if accuracy is to be attained. The cleanliness and good state of your equipment will be reflected in the work you produce. Never allow other people to use your equipment. Pens and brushes take on the personality of the user and after being in someone else's hands will never feel the same.

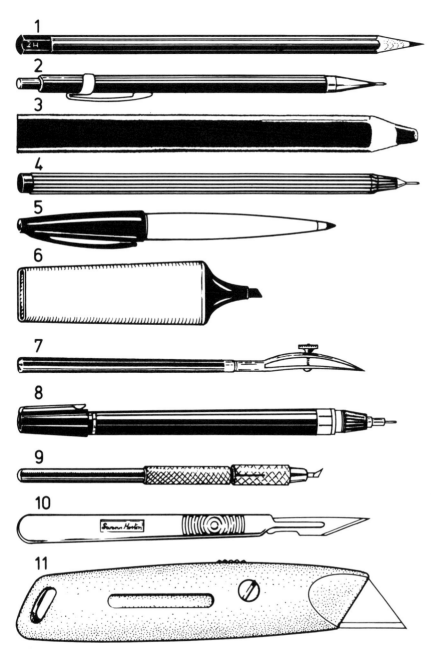

Writing tools

1 Pencils – HB, 2H and 4H used for sketching or roughing out lettering and projecting lines.
2 Technical, propelling or mechanical pencil used with HB, 2H and 4H leads.
3 Carpenter's pencil for filling in letterforms and producing roughs.
4 Fine tipped fiber pens, water soluble and waterproof, useful for mapping out lettering.
5 Medium tipped fiber pens for filling in letterforms when evaluating letter and word spacing.
6 Wide tipped fiber pens of various sizes used for roughing up color visuals.
7 Ruling pen used for ruling lines in any color on board and paper surfaces, with either inks or water soluble paints.
8 Technical pen (0.2) for mapping out letterforms or for finished artwork reproduction. A technical pen has the added advantage of fitting into a compass attachment for scribing circles.

Cutting tools

9 Swivel head cutter used when cutting stencils and cut out letterforms.
10 Scalpel for cutting out stencils, letterforms and general cutting (10a blades). An X-Acto knife with a no. 11 blade is similar.
11 Craft (mat) knife for heavy duty cutting of board.

Task

Collecting materials

Seek out several art supply shops and make notes on the quality and cost of individual items before committing yourself to purchase.

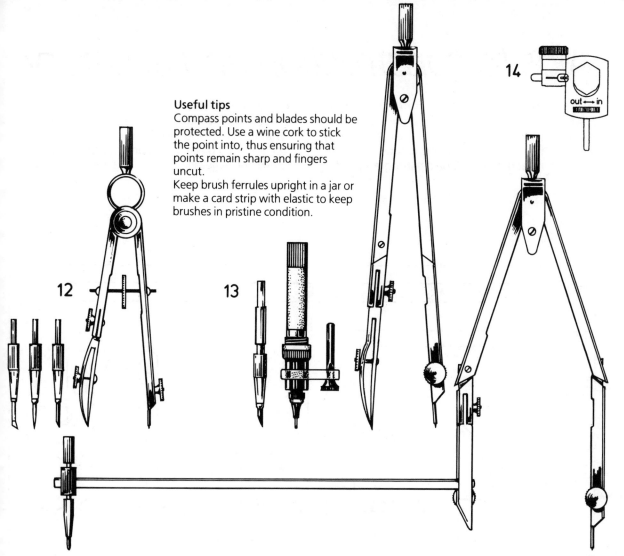

Useful tips

Compass points and blades should be protected. Use a wine cork to stick the point into, thus ensuring that points remain sharp and fingers uncut.

Keep brush ferrules upright in a jar or make a card strip with elastic to keep brushes in pristine condition.

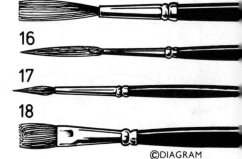

Compasses

12 Small springbows, with interchangeable cutter, divider, lead and ink attachments, for constructing letterforms or cutting arcs and circles.

13 Large compass with interchangeable lead, technical pen, and ink attachments, together with the same compass fitted with an extension bar, for drawing extra large circles.

14 Compass attachment for holding all types of pens and pencils.

Brushes

15 Chisel ended, long hair sable for signwriting. A no. 4 is a useful size to begin with for sans serif letterforms.

16 Writer's (pencil) point brush, long hair sable for Roman and script letterforms.

17 Artist's pointed long hair sable brush for brush script letterforms.

18 Square ended sable ticket writer's brush, ¼" (6 mm) wide, used for brush letterforms.

General

19 Plastic type eraser.

©DIAGRAM

Task
Storage

Once you have collected your first few items, it is advisable to obtain a container to put them in. Plastic, wood or woven material finishes are preferable to metal as this can damage the equipment.

Selecting equipment

Selecting your equipment is important. You must feel at ease when using instruments, so choose carefully. Check the balance of a compass and the feel of a writing implement.

Aids to construction and accuracy

There are many items which are useful additions to a lettering artist's tool kit. As well as the usual measuring and projecting tools, there is a vast array of guides for drawing circles, ellipses and curves. Other useful additions include a pantograph and proportional dividers for enlarging, reducing and proportional work. You are the best judge of whether or not your require such aids, though generally, if a piece of equipment assists both in speed and accuracy, its purchase may be justified.

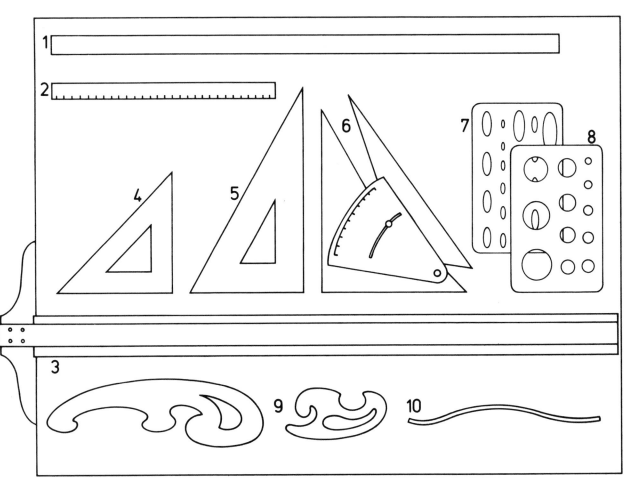

Measuring and projecting aids
1 Steel cutting rule for trimming work.
2 Clear acrylic plastic rule.
3 Tee square.
4 45° perspex set square – a useful size is 10″.
5 30° and 60° perspex set square (triangle) – a useful size is 10″.
6 Adjustable set square (triangle) which can be altered from 0 to 45° or 90° to 45°. These are ideal for projecting diagonal lines in letter construction; 10″ and 6″ cover most work.

Guides for drawing regular and irregular curved shapes
7 Ellipse guides – not essential but the 50° and 55° are quite useful.
8 Circle template – the smaller sizes are useful when a compass proves difficult to maneuver.

9 French curve set – a useful addition when accurate, quick curves are needed.
10 Flexicurves – PVC coated with lead core; these are good for joining up plotted points into a curve.

Cutting mats (*left*)

Cutting mats are amazing. As the knife passes through the work the surface of the cutting mat closes behind it leaving a smooth surface which cannot deflect the blade in the direction of a previous cut. The green non-slip, no glare surface of the cutting mat is printed with a grid as an aid to accurate cutting.

Translucent cutting mats

These possess all the qualities of the green cutting mats but have the added attraction of being suitable for use on a lightbox. Translucent cutting mats are ideal for film assembly where accurate cutting of back-lit transparencies is essential. As a further aid to precision the non-slip surface is printed with a 5 cm grid.

Enlarging and scaling aids

11 Pantograph – for enlarging and reducing letterforms, logotypes or drawings, etc, by copying the original.

12 Proportional dividers – for dividing lines into equal parts.

Pantograph

Pantographs are used to enlarge or reduce drawings, designs and layouts by copying from the originals. Wooden pantographs may be obtained with various ranges of settings as illustrated.

Task

Research and investigation
Go to your local suppliers and investigate the items described in this section. Make notes in your notebook.

Task

Awareness
Become aware of the signs and posters around you. See if you can discover which methods have been used to produce them.

Lettering guides
Technical pen guides

They ensure a constant ratio between letter height and line width. In addition, the letter forms are designed to minimize ink build-up or fill-in and to give maximum legibility, so they are particularly suitable for drawings where microfilming or reduction/enlargement is required.

This first chapter has shown the tools and materials which can be used to produce letterforms. Now that you have prepared your work area and become familiar with the materials available, you are ready to put them to use in letter construction.

Chapter 2

ABCDEFGHIJKLM

ABCDEFGHIJKLM

ABCDEFGHIJKLM

ABCDEFGHIJKLM

ABCDEFGHIJKLM

LETTER AND ALPHABET FORMS

This chapter is about alphabet forms. We begin by looking at the different alphabet groups, from serifed through to decorative, and the variations within the groups when letters are expanded, condensed, italicized and made bolder within their named style. We will consider the names used to describe the component parts of letterforms generally as well as within a style. Finally, we will look at the application of letterforms to the way in which letterspacing is determined, how word spacing is arrived at and how wide apart lines of words should be spaced to give good readability.

NOPQRSTUVWXYZ

NOPQRSTUVWXYZ

NOPQRSTUVWXYZ

NOPQRSTUVWXYZ

NOPQRSTUVWXYZ

©DIAGRAM

Alphabet styles

Letterforms or alphabet styles are divided into groups. There are thousands of styles in use so it is much easier to identify a particular typeface (lettering style) once the faces are grouped. Some of the groups contain numerous typefaces and others just a few, but all are given a name for identification.

In the simplest form of division the groups are:

serifed, Sans serif, script and decorative. However, it is difficult to place a style just within a basic division because of the quantity of faces within a given group. Therefore, the groups are sub-divided in order to classify the style more easily. You will find it easier and more useful to read the whole chapter before studying the individual typefaces in any depth.

Serifed styles

These have serif endings to certain strokes which differ from style to style. They fall into the following sub-divisions.

1 Old style
This division includes letters which were originally based on pen forms but have subsequently been re-drawn. Letterforms (typefaces) falling into this category have the greatest diagonal stress. The example shown is Bembo Roman.

2 Transitional
Styles in this division include those in which the stress is still diagonal but moving towards the vertical. The example shown is Baskerville.

3 Modern
Here the stress is vertical and the thin strokes very fine. The letterforms in this category have hairline serifs. Bodoni bold, the example shown, is one of the best known in this division.

4 Slab serif (Egyptienne)
The serifs in this division are blocked and solid but unbracketed. The example shown is Rockwell.

5 Clarendon
Again the serifs are solid but here they are bracketed. The example shown is Clarendon.

6 Latin
This time the serifs are triangular in form. The example is Cortez.

1 ABCDabcd

2 ABCDabcd

3 **ABCDabcd**

4 ABCDabcd

5 **ABCDabcd**

6 **ABCDabcd**

Task
Scrap book
Buy a scrap book and divide into sections – one for each letter style. Pencil in headings (to be filled in at a later date) with a soft pencil.

¹ABCabc ²ABCabc
³ABCabc ⁴ABCabc

Sans serif styles

These are plain letterforms, without serifs, and they fall into four main sub-divisions.

1 Geometric

Letterforms which appear to be generated with compass and drawing aids with strokes of one thickness. The example is Futura Book.

2 Humanist

Styles which are based on the individual qualities of the letters themselves and do not project uniformity of shape as in constructive styles. The example is Gill Sans.

3 Grotesque

A large group of styles, all semi-constructive but still retaining individual letter qualities where the forms are not totally forced to produce uniformity. The example is Grotesque 216.

4 Neo-grotesque

Constructive styles based on the original grotesque but with certain letters forced to conform to the overall alphabet design. In the example, Helvetica Regular, the lowercase c is forced to fit the rounded letterforms.

Task
Tracing
Using a sheet of tracing paper, ruler and fine point fiber pen, refer to your scrap book and choosing a simple style, trace over the letterforms and afterwards fill in the centers.

¹ABCDabcde

²ABCDabcde

³A B C D abcde

Scripts

A division which contains many free styles – letterforms which are created without the use of drawing aids other than the instrument or brush with which they were written.

1 **Brush scripts (round or pointed).** Forms drawn with a brush. The example is Slogan.
2 **Brush scripts (square).** Drawn with a square ended pen or simulated to give that effect. The example is Ondine.
3 **Pen forms**. Produced with a pointed pen or simulated to give that effect. This example, Palace script, is a simulated copper plate pen form.

Task

Collecting styles
Using the examples as a guide, search through magazines, newspapers, leaflets or any printed matter for similar letterforms. Cut them out and stick into the appropriate section in your scrap book.

Decorative

A group containing many adorned styles based on the other groups mentioned. The embellished styles may, in essence, be from the serifed, Sans serif or script groups.
The examples shown here are:
1 Flash (Sans serif)
2 Astur (script)
3 Union Pearl (serifed)
4 Sapphire (serifed)
5 Romantiques no. 5 (a mixture of styles)

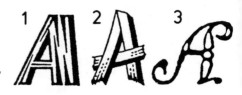

©DIAGRAM

Terminology

Some of the terminology (or nomenclature) commonly used when discussing the subject of lettering is given below. This nomenclature is frequently used in the analysis of particular styles. The component parts of letterforms named here (1 to 26) are based on a Roman serifed style. Different designs will have other names to define specific traits within the style, but general terms, such as cross stroke, main stroke and stress, for example, remain. The differences are in the way strokes are terminated or embellished.

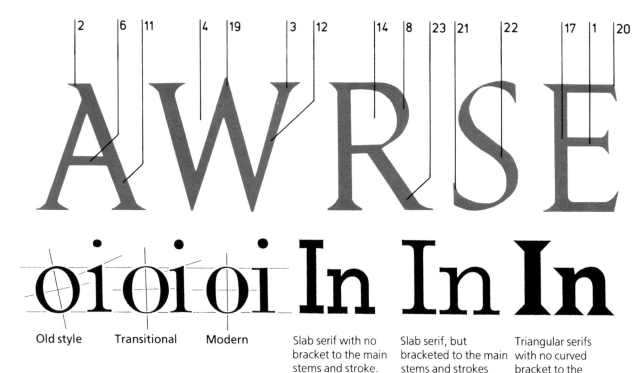

Old style Transitional Modern

Slab serif with no bracket to the main stems and stroke.

Slab serif, but bracketed to the main stems and strokes

Triangular serifs with no curved bracket to the main stems and strokes.

Stress
The stress of a style is related to round letterforms and appears in all styles where there is a weight difference between main strokes on the round letters and the thinning effect either near the x line and base line, or on them. The position at which stress (the thinnest part of the letter O) is positioned varies with each alphabet style. Compare the positions of stress shown in the examples of Old style, Transitional and Modern letterforms (*above*).

Degrees of stress
The degrees of stress fall into three main groups. Letterforms with maximum diagonal stress are called Old style. Letters with stress deviating only slightly from the vertical are called Transitional and letters with vertical stress are called Modern.

Serifs
In each instance the serif construction on straight or oblique letterforms within each group also varies. See the illustrations of the letter I and n (*above*) for examples of different types of serifs.

Shading
The widest part of a round letterform and the tapering to the thinnest part is known as shading. Shading varies with the stress of the letterform, but the widest part of the shading is always at 90° to the thinnest part (the stress).

Components of letterforms

1 Arm
2 Beaked serif
3 Bracketed serif
4 Counter
5 Cross stroke
6 Cross stroke or bar
7 Curved stroke
8 Curved stroke forming the bowl of the letter 'R'
9 Curved stroke forming the bowl of the letter 'g'
10 Curved stroke forming the loop
11 Diagonal main stroke or stem
12 Diagonal thin stroke
13 Ear
14 Inner counter
15 Ligature, two letters joined
16 Link
17 Main stroke or stem
18 Maximum point of stress
19 Pointed apex
20 Sheared serif
21 Sheared terminal
22 Spine main stroke
23 Tail
24 Terminal
25 Swash
26 Flag

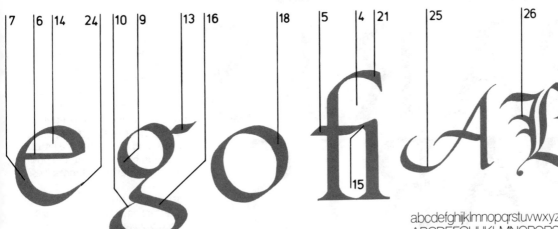

©DIAGRAM

Roman and italic letterforms

Vertical or upright letters are also called Roman, as compared to slanted or tilted letters, which are called italic.

Task
Recognition

Look through some fresh samples of lettering and try to put them in the right group without referring back.

Task
Stress and shading

Study the points of stress and shading and try to recognize them in your scrap book samples.

Emphasis

A number of styles have more than one weight of letterform. Such typefaces or styles are called families. A family consists of the normal weight, or "Roman" for the style, and there may be a light weight, a medium, a bold or an extra bold version of the style. Some styles also have italics which match the Roman weights. The question of emphasis does not end there as some even have condensed and extended versions of the style, where the letterforms are squashed or stretched.
Thirteen examples of letterforms, showing variations from Helvetica are shown (*right*).

Task 12
Naming the parts

Using the terms to describe letterforms, name as many parts of the traced letters as you can.

abcdefghijklmnopqrstuvwxyz
ABCDEFGHIJKLMNOPQRSTUVWXYZ

abcdefghijklmnopqrstuvwxyz
ABCDEFGHIJKLMNOPQRSTUVWXYZ

abcdefghijklmnopqrstuvwxyz
ABCDEFGHIJKLMNOPQRSTUVWXYZ

abcdefghijklmnopqrstuvwxyz
ABCDEFGHIJKLMNOPQRSTUVWXYZ

abcdefghijklmnopqrstuvwxyz
ABCDEFGHIJKLMNOPQRSTUVWXYZ

abcdefghijklmnopqrstuvwxyz
ABCDEFGHIJKLMNOPQRSTUVWX

abcdefghijklmnopqrstuvwxyz
ABCDEFGHIJKLMNOPQRSTUVWXYZ

abcdefghijklmnopqrstuvwxyz
ABCDEFGHIJKLMNOPQRSTU

abcdefghijklmnopqrstuvwxyz
ABCDEFGHIJKLMNOPQRSTUVW

abcdefghijklmnopqrstuvwxyz
ABCDEFGHIJKLMNOPQRSTUVWXYZ

abcdefghijklmnopqrstuvwxyz
ABCDEFGHIJKLMNOPQRSTUVWXYZ

abcdefghijklmnopqrstuvwxyz
ABCDEFGHIJKLMNOPQRSTUV

abcdefghijklmnopqrstuvwxyz
ABCDEFGHIJKLMNOPQRSTUV

Letter spacing

We have so far looked at alphabet designs and their constituent parts. Now we are going to look at the spacing of individual letters to form words.

1 PARIS

2 PARIS

3 PARIS

4 PARIS

5 PARIS

1 Air space.
2 Negative space.
3 Positive space.

Examples of the word PARIS spaced mathematically and optically

1 Mathematically spaced, ie, equal amounts of space between the letters.
2 Optically spaced using the space value between the P and A as the criterion for the rest of the word.
3 The spacing between the A and R in **1** used as the criterion, then optical spacing of the P, I and S.

4 The spacing between the R and I in **1** used as the criterion, then optical spacing.
5 The spacing between the I and S in **1** used as the criterion, then optical spacing.

Harmony of letterforms

Both the legibility and readability of a piece of work are determined by the sensitive use of space. The space between letterforms is as important as the space within the letter – the counter and inner counter – and the letter itself. It is the balance of the counters that is crucial to letter spacing. The negative areas, those surrounding and within the letter, must be in harmony with the positive areas, the letterforms themselves.

Optical spacing

The letters have to appear equally spaced optically. Letter spacing cannot be done mathematically because letterforms have different shapes and therefore different spacing requirements. Compare example 1 of the word PARIS, which is spaced mathematically, with examples 2 to 5 which are spaced optically.

Criteria

This exercise illustrates that the first two characters lettered govern the spacing for the rest of the word. In the fifth example it can be seen that the A and R almost touch because the I and S were too close in the original, causing a tightly spaced word. The reverse can be said for no. 2, for with the space between the P and A too great, the result is an overspaced word.
Of the remaining two versions, no. 3 and no. 4, the latter is the better spaced. The word looks well spaced, has rhythm and the forms are in harmony without appearing overspaced. It also leaves room to maneuver.

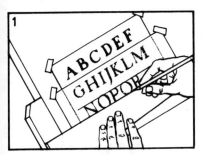

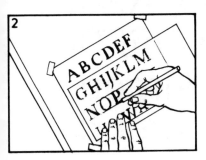

The three letter method

This is an easy way of judging the spacing to use, but remember to always analyze the letter combinations of the word before commencing.

1 Tape a sample alphabet sheet to the drawing board, overlay with tracing paper, and draw in a base and cap line to the size of the alphabet.
2 Trace carefully over the P with a black fiber tipped pen.
3 Move your tracing sheet to the letter A on the alphabet sheet and letter space the P and A. Remember it is the space you use now which will set the standard for the remainder of the word.
4 Move your tracing sheet to the letter R. Blank off the letters on either side using white paper.

This will ensure the Q and S do not interfere with your judgement of the optical space. Move the tracing sheet left and right until you feel the space between the A and R is the same as the P and A.

5 Letter in the R.
6 Move the tracing sheet to the I. Blank off the H and J and position the I so that the optical space between the A and R equals that between the R and I. If in doubt, mask off the P for it may be clouding your judgement. When you are happy with the position, letter in the I.
7 Reposition for the S, masking the letters either side and, if necessary, the P and A. Optically space the S and trace off.

Patterns

Look for letter combinations with similar patterns. Study the word INDIANAPOLIS and note the combinations. All straight to straight letters require the same amount of space, round to straight the same as straight to round, straight to oblique the same as oblique to straight and so on. Patterns are there and can be found in many words.

Letter combination

Before deciding on the letter spacing to use, study the combinations of letterforms. Establish the rogue combinations which create lots of air space when next to each other. Here are some examples:

AA LA TT TV TW TY WY

ft fy rf rt ry ty

If there are straight sided letters followed by round letters, leave sufficient space between the straight forms to allow for the round forms to be closely spaced. 00 together create lots of air space.

Task

Cut-out

Cut out some fairly large lettering and practice letter spacing by arranging in various positions.

Task

Tracing

Now try tracing some words of your choice and use the three letter method to determine the spacing.

©DIAGRAM

Word and interlinear spacing

When more than one word is to be lettered, the words require spacing. This word spacing is strongly linked to letter spacing in that if too much space is left between the words the rhythm of a line is broken and readability impaired.

LONDON|HEATHROWIA|RPORT

LONDON HEATHROW AIRPORT

Londoni Heathrowi Airport

London Heathrow Airport

I method
A useful method of spacing words is to insert either a capital I or a lower case i, depending on which form the lettering is in, between the words. The rhythm this creates is in complete harmony with the letter spacing adopted, because it is based on the same letter space value either side of it.

Example
In the above example the letter I or i is letterspaced between the words. Here LONDON is treated as if the I is part of the word. The H for HEATHROW is now spaced as if it were part of the first word and so on to the end. The spacing I's are lettered in pencil and removed when the work is finished.

Task
Using i's
Space the phrase using a different type style. Use a fiber pen on tracing paper and letter in the i's with an HB pencil.

LONDONrHEATHROWrAIRPORT

LONDON HEATHROW AIRPORT

Londonr Heathrowr Airport

London Heathrow Airport

R method
For those who like their words a little more widely spaced, the lower case r can be substituted for the i, giving a more open line. Under no circumstances should a wider letter be used as it would result in a totally overspaced line.

Example
In the above example the lower case letter r is included as part of the text for spacing purposes.

Task
Observation
Now that you understand letter and word spacing, look at signs, magazines and newspapers and make judgements on the spacing used.

28

Napoleon Wellington Waterloo

1

Napoleon Wellington Waterloo

2

Interlinear spacing
There is another element of spacing which needs to be looked at and that is line spacing. This spacing left between lines of lettering is called interlinear space.

Clashing
When using capitals and lowercase (small letters or minuscules), it is necessary to insert extra space between the lines to prevent the descenders of one line clashing with the ascenders of the next. This space can be minimal when only single words are placed one above another, but where longer lines of lettering are used it is essential that sufficient interlinear space is used, otherwise readability can be affected.

Examples of different line spacing
Example 1 illustrates close line spacing in which the ascenders and descenders of individual lines touch. It can be seen quite clearly that the letter p in Napoleon and letter l in Wellington clash as do the letters g and l in the second and third lines. Example 2 illustrates open line spacing. Here it can be seen that an adequate amount of space has been left in order to prevent the ascenders and descenders of two lines of text from clashing.

Readability
The readability of text is dependent upon letter spacing, word spacing, line length and interlinear spacing. When reading a sign, poster or text, the eye scans from left to right to read the line of text and then must travel the whole line length back to the left before reading the following line. If the interlinear space is too little, the eye may read the same line twice. The line length is also directly related to the interlinear space required – the longer the line length the more interlinear space needed.

Task
Differing styles
Using the words in the example, letter them out in various styles. You will see that alphabet styles which have large x heights require more interlinear space than styles with small x heights. This is because small x height styles visually create space between lines, whereas large x height styles do not.

Line length
An optimum line length is 10 words or 60 letters (or characters) including spaces and punctuation when calculating. However, line lengths of 8 to 12 words are acceptable.

©DIAGRAM

29

Chapter 3

This chapter discusses three different ways in which alphabets can be generated. The first example, a Sans serif style constructed with a compass and set square (triangle) is designed to give you a quick result. The emphasis here is on the accurate use of equipment and following instructions. The drawing aids will give you confidence and, handled properly, will enable you to create a useable geometric style.

The second example is a Roman serifed style. The skill required here is in copying th

Capitals, lower case and numerals for the three alphabet styles in this chapter:
1 Sans serif
2 Roman
3 Brush script

1 ABCDEFGHIJKLMN

abcdefghijklmnopqrst

2 ABCDEFGHIJKLMN

abcdefghijklmnopqrstu

3 ABCDEFGHIJKLM

abcdefghijklmnopqr

TECHNIQUES

letterform outline via a square grid. The letters are plotted using the grid reference points and then the points are joined up to form the letter. In producing this style you will learn how to coordinate a critical eye with command of hand.

The third alphabet is brush script, a free hand letterform which gives the informal feel of having been created spontaneously – that just whizzed-off effect. There is actually nothing further from the truth – to create the relaxed feeling of the form demands complete control over eye, hand and finger movements. The knowledge that has been gained from constructing the first two alphabets will be of great help in producing brush script.

You will also find hints in this chapter on equipment, methods and sequences to aid in the construction – read these carefully and you will save yourself a considerable amount of time.

OPQRSTUVWXYZ
uvwxyz 123456789

OPQRSTUVWXYZ
vwxyz & 1234567890

NOPQRSTUVWYX3
stuvwxyz123456789

Sans serif: proportions

In the next eight pages we show you how to construct a Sans serif alphabet. This compass constructed alphabet is built up on a grid to enable you to produce regular letterforms in a consistent style. We will begin by looking at the relative positions of the capital and lower case letters, together with some of the terminology used in the construction details given in the following pages. Instructions on how to construct your grid are shown opposite.

Tools and materials
To produce the Sans serif alphabet you will need the following:

1 Drawing board
2 Tee square
3 Adjustable set square (triangle)
4 Compass
5 Ruler
6 2H pencil
7 Eraser
8 Masking tape
9 Tracing pad
10 Stiff paper

Relative positions of capital and lower case letters
Newcomers to lettering often become confused as to the relative positions of the lower case letters when combined with capitals.
The grid lines used to align characters are the capital or ascender line, x line, base line and descender line.

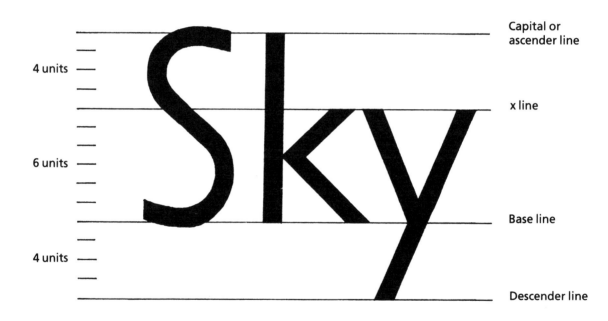

4 units — Capital or ascender line

x line

6 units — Base line

4 units — Descender line

Task
Constructing the grid
Decide on the height you wish to draw your capital letters, take a sheet of stiff paper, tape it to your drawing board and draw cap and base lines to your chosen height. Divide the height into ten equal parts. Extend the cap and base lines to the right of your unit line and draw up the grid.

Capital or ascender line
All capital letters, which are 10 units high, sit on the base line and extend to the cap line.

x height characters
x height characters are 6 units high. The x line to base line forms the x height and contains the following letters – a, c, e, i, m, n, o, r, s, u, v, w, x, and z. All of these letters, with the exception of the dot on the letter i, are x height letters.

Ascending characters
Ascending characters are 10 units high. All ascending characters b, d, f, h, k, l and t sit on the base line with the ascenders projecting from the x line to the capital or ascender line, which is called the ascender area.

Descending characters
Descending characters are 10 units high. Characters which have descenders, namely g, j, p, q and y have their x height area between the x and base line and their descenders project from the base line to the descender line – the descender area.

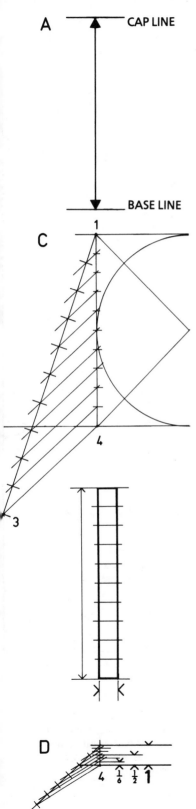

A CAP LINE

BASE LINE

C

1

4

3

D

4 $\frac{1}{6}$ $\frac{1}{2}$ 1

Constructing the grid

A Tape a sheet of stiff paper to your drawing board and proceed as follows. Select the height of your capital letters; this obviously determines the height of your base line to cap line and therefore your grid. You may find it easier to begin with a height of 2"-3" (50 mm-75 mm) (*see left*).

B Draw a square, two diagonals and a circle as shown (*right*). Draw in a dotted compensation line ⅙ of a unit above and below the base and cap line for positioning round letterforms. For details of how to calculate unit measurements used in the construction of the sans serif alphabet see **C** and **D** below. In the illustration (*top right*) we have shown reference points 1, 2, 3 and 4, which may be used in the construction of letterforms. Other reference points are gained by projecting lines or stepping off widths of the stroke.

C Divide the height of a letter into 10 equal units (*see left*). From 1 draw a line at an angle away from the upright, ie towards 2. Using a ruler, measure 10 equal parts down the line. Any measurement can be used provided there is enough room on the sheet. From 3, the last equal part, draw a line linking it with 4. Using an adjustable set square, set to the angle formed by line 3/4, make and project parallel lines from the divided line so that they intersect with the left hand side of the grid. Now draw short lines horizontally to complete the scale.

D Obtain ⅙ of a unit using the following method. Transfer a tenth unit and subdivide it into six equal parts using the same method given in **C** above. Mark the units onto the edge of a piece of card. This is used for transferring measurements (stepping off units) when constructing letterforms. Keep the card in a safe place – it will be used throughout the alphabet construction (*see bottom left*).

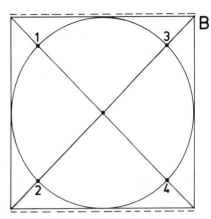

B

1 3

2 4

POP

POP

Compensation line

When round letters are drawn to the same height as straight ended letters they appear smaller because the head and base of straight letterforms are solid in comparison to the thinning out of a rounded letter, which if positioned on the cap and base line has only a small proportion of the form touching. An adjustment of ⅙ of a unit is made so that round letters appear optically the same height as straight letters. A dotted compensation line is used in the construction of round letterforms.

Sans serif: construction techniques

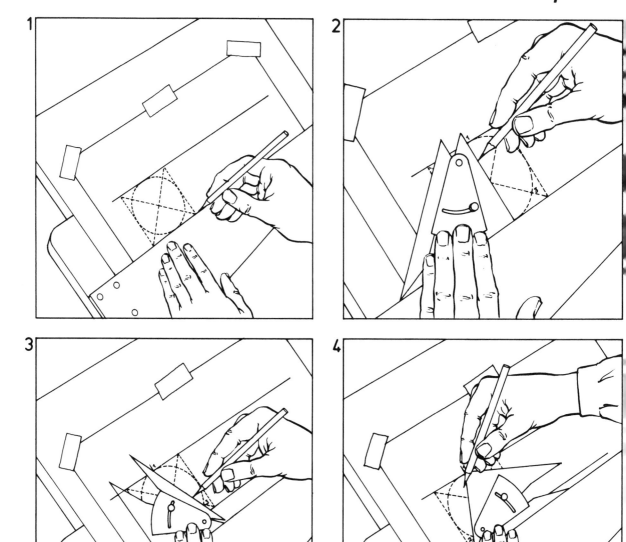

Step by step

1 To draw the letter A (see page 38) place tracing paper over the grid and draw cap and base lines.

2 Draw a vertical line through the center of the grid.

3 Using an adjustable set square (triangle), join 1 to 3.

4 Turn the set square through 90° and join 1 to 2.

5 Take a card unit gauge and mark a ½ unit either side of the diagonal lines.

6 Using an adjustable set square project parallel lines from the units marked in step 5.

7 Take the gauge and measure two units down from the center of the circle.

8 Project horizontal lines for the cross bar of the letter A and finish the letterform at the top and bottom.

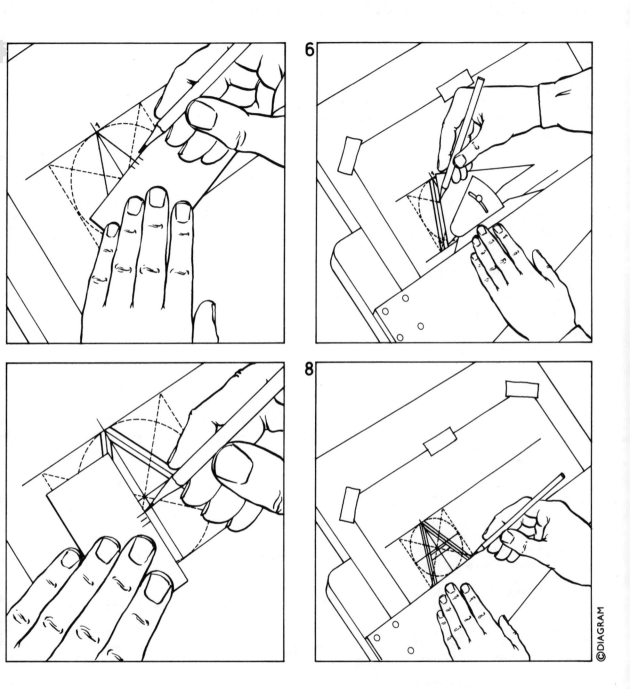

Task
Construct a letter A, following the step by step instructions, using a 2H pencil on tracing paper and working over your grid. Make careful note of the reference points before beginning.

Task
When you are satisfied with the construction of your letter A, continue with the rest of the alphabet.

Accuracy hints
1 Make sure that you can see the line being drawn as you work.
2 All preliminary drawings should be carried out with a sharp 2H pencil.

Sans serif: capital letters 1

To help you gain a basic understanding of the system, the letter S has been produced in stages; this is probably the most difficult letter to generate and therefore deserves more attention. If you feel you would like to begin by producing the letter S, do so, as once this form has been mastered the remainder of the alphabet is relatively simple.

A Draw a line at an angle of 45° from 1 and where this intersects with the grid diagonal, draw a vertical line, 2 (new center line). Step off ⅙ of a unit at the cap line, 3, and base line, 4, and project horizontal lines. Step off a ½ unit either side of the center line, 5, then 1 unit for 6, 7 and 8. Project horizontal lines on the left hand side of the grid as shown.

B Step off a ½ unit from the new center line to the right and draw a vertical line. The reference points on this diagram show the extent of the two circles, which form the basis of the letter S. From 1 and 2 project lines at an angle of 45° towards 4. Repeat from 2 and 3 towards 5. Where the lines intersect is the central point between 1 and 2, and 2 and 3.

C Now project 4 to the left and mark the intersection with the first vertical line, 6. Repeat from 5, but extend to the second vertical line, 7. These points are the centers of the four circles used to construct the letter S.

D Using 6 as the center point open up the compass to the arrows shown and draw two circles. Repeat the procedure using 7 as a center point.

E Using 6 as a center point open up to the arrows shown and scribe two arcs to the left. Repeat the procedure using 8 as a center point. Project two parallel lines 9 to 10 and 11 to 12. Draw a line from 13 to the base of the grid and from the center to the cap line.

F Finished letterform.

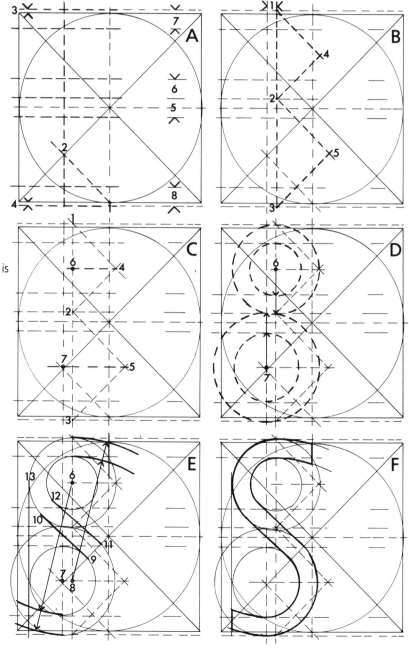

Using a 45° set square (triangle) to project a given thickness from a horizontal to a vertical or vice versa

For example, assume you have measured a unit of thickness on the main stroke of the letter D and having projected vertical lines you now wish to mark the thickness of the cross strokes. This can be done without a further stepping off of units as follows. The unit measured is "x." To project the same unit vertically, draw a line at an angle of 45° from 1; where this line intersects the vertical at 2, project a horizontal line. This will give you the same unit "y" but in the vertical plane. This method can be applied to many of the letterforms including the letters E and F for example.

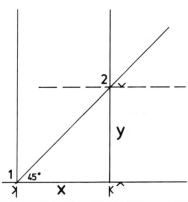

Using a 45° set square to divide a line equally

If you need to to find the center of an arc or circle when constructing a letterform (such as for example the letter B) one method is outlined below. From either end of the line X/Y project a line at an angle of 45° inwards; at the point of intersection project a line at right angles to the line to be divided; the intersection marks the center of the line X/Y.

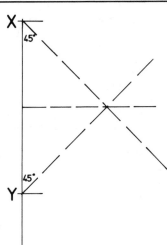

Using a compass to divide a line equally

Open the compass up to more than half the length of the line to be divided. Place the compass point on X (one end of the line) and scribe a semi circle. Repeat using Y as the center point. Where the arcs intersect, join with a straight line. The center is where the straight line cuts X/Y.

Sans serif: capital letters 2

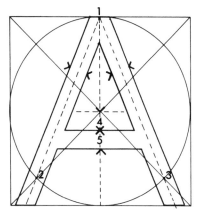

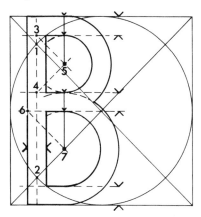

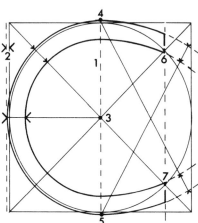

A

Draw a vertical line from the cap line to the base line through the center of the circle. From 1 draw a diagonal line through 2 to the base line. Repeat from 1 to 3. Mark a ½ unit either side of the diagonal lines and project parallel lines to form the main strokes of the letter A. From the center of the circle mark down 2 units and project horizontal lines for the cross bar of the letter A.

B

Draw a vertical line through 1 and 2. Step off a ½ unit either side and draw vertical lines to form the main stroke. Step off 1 unit from the center of the circle, cap line and base line and project horizontal lines to the left. From 3 project a line at an angle of 45° towards 5. Project a line at an angle of 45° from 4 to 5 to form the center point for the upper arcs. Project a line at an angle of 45° from 6 to 7 to form the center for the lower arcs. Position the compass point on 5 and scribe arcs from the radius marks; repeat the procedure from 7.

C

Draw a vertical line through the center. Step off ⅙ of a unit at 2 and draw a vertical line. Step off 1 unit. Scribe semi-circles, using 3 as a center point, from 4 to 5. Using 4 as a center point, scribe an arc from 5 to the right. Repeat using 5 as a center point to scribe an arc from 4 to the right. Draw a vertical line through 6 and 7 to produce sheared terminals.

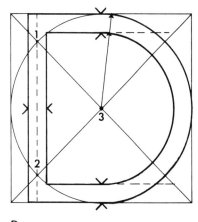

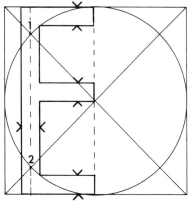

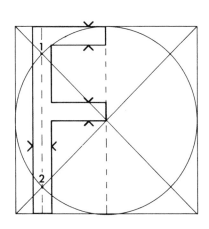

D

Draw a vertical line through 1 and 2. Step off a ½ unit either side of the line drawn. Draw vertical lines to form the main stroke of the letter D. Step off 1 unit at the cap and base lines and project horizontal lines. Using 3 as a center point, scribe two semi-circles using the radii marked.

E

Draw a vertical line through 1 and 2. Step off a ½ unit either side of the line drawn. Draw vertical lines to form the main stroke. Draw a vertical line through the center of the circle. Step off 1 unit up from the center line. Repeat the procedure at the cap and base lines. Project horizontal lines to the main stroke.

F

Follow the instructions for the letter E, but omit the base cross stroke.

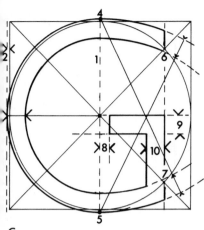

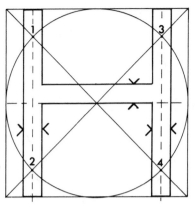

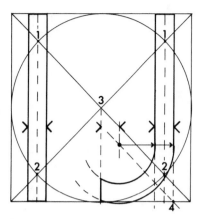

G

Follow the instructions for the letter C, but with the following additions. Step off a ½ unit from the center vertical line to the right. Draw a short vertical line, 8. From the center step down 1 unit to form the cross bar of G. Project a horizontal line towards the center. From the vertical line 6/7, step off 1 unit to the left, 10, to form the short vertical stroke of G.

H

Draw a vertical line through 1 and 2. Step off a ½ unit either side. Repeat the procedure for 3 and 4. Draw vertical lines to form the main strokes of the letter H. Step off 1 unit above the center line. Project horizontal parallel lines to form the cross bar of the letter H.

I

Draw a vertical line through 1 and 2. Step off a ½ unit either side. Draw 2 parallel vertical lines.

J

Draw a vertical line through 1 and 2. Step off a ½ unit either side. Draw two parallel vertical lines. Project a line at an angle of 45° upwards from 4. From 3 draw a vertical line to the base and step off 1 unit to the right of the line. Draw a short vertical line through this point and where this intersects with the 45° diagonal line, scribe two arcs to the radii shown.

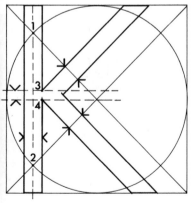

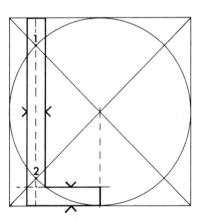

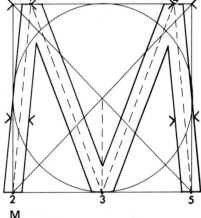

K

Draw a vertical line through 1 and 2. Step off a ½ unit either side and draw vertical parallel lines. Project a horizontal line from the center of the circle to the left hand side of the grid. Step off a ½ unit upwards and project a line to the right. From 3 project a 45° line upwards and step off 1 unit width. Project a parallel line. Repeat the procedure from 4 but in a downwards direction.

L

Draw a vertical line through 1 and 2. Step off a ½ unit either side and draw vertical parallel lines. From the base line step up 1 unit and draw a horizontal line from the main stem to the center of the circle to end the base stroke.

M

Drop a vertical line from the center of the circle to the base line, to give 3. Step inwards 1 unit from both corners at the top of the grid to give 1 and 4. With diagonal lines, join up 2 to 1, 1 to 3, 3 to 4 and 4 to 5. Step off a ½ unit either side of each of the lines as shown and project parallel lines using an adjustable set square.

39

Sans serif: capital letters 3

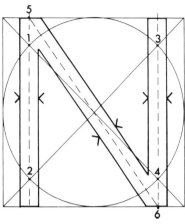

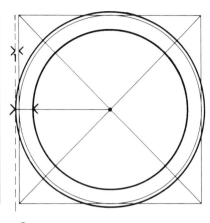

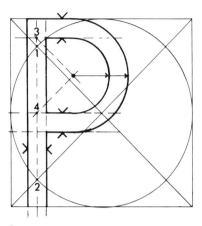

N
Draw vertical lines through 1 and 2, and 3 and 4. Step off a ½ unit either side of both lines and project vertical parallel lines. Join 5 to 6 with a diagonal stroke. Step off a ½ unit either side of the line and using an adjustable set square (triangle), project parallel lines.

O
Step off ⅙ of a unit at the left hand side of the grid. Project a line from the center of the circle to the left hand edge. Step off 1 unit from the extreme left hand side of the grid towards the center. Using the center of the circle as a center point scribe two circles as shown.

P
Draw a vertical line through 1 and 2. Step off a ½ unit either side. Draw two vertical parallel lines. Step off 1 unit from the cap line to 3 and 1 unit from the center of the circle downward. Project horizontal lines. From 3 project a line at an angle of 45° down and from 4 project a line at an angle of 45° upwards. Where the lines cross use as the center point and scribe arcs as shown.

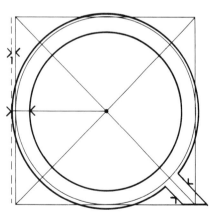

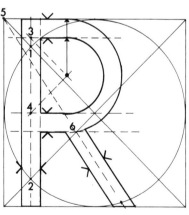

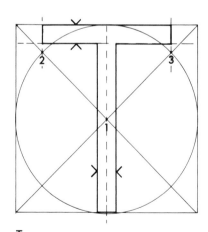

Q
Follow the instructions for the letter O, and add a tail by stepping off a ½ unit either side of the lower right hand diagonal stroke. Project parallel lines to the circle.

R
Follow the instructions for the letter P, and add a tail by projecting a diagonal line from 5 through 6. Step off a ½ unit either side of the line and draw parallel lines using an adjustable set square.

T
Draw a vertical line through 1 from the cap line to the base line. Step off a ½ unit either side of the line and project two parallel lines to form the main stroke of T. Project vertical lines to the cap line from 2 and 3. Step off 1 unit down from the cap line and project two horizontal lines to form the cross bar of the letter T.

40

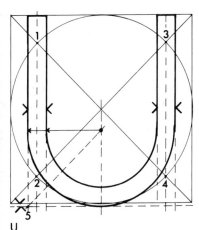

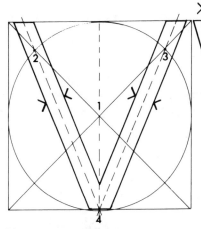

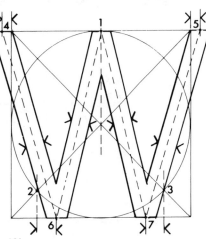

U

Draw vertical lines through 1 and 2, 3 and 4, from the cap to base lines. Step off a ½ unit either side of the lines and project parallel and vertical lines. Step off ⅙ of a unit beneath the base line and draw a horizontal line. From the center drop a vertical line towards the base and project a line at an angle of 45° from 5 to generate the center point. Scribe two semi circles to the radii as shown.

V

From the center drop a vertical line to the base. From 2 and 3 project diagonal lines to 4. Step off a ½ unit either side of the diagonal lines drawn and project diagonal lines to form the letter V.

W

Project a vertical line from the center to 1. Drop two vertical lines from 2 and 3 to the base. Step off 1 unit to the right of the line to form 6 and left of the line to form 7. From the top left of the grid step off a ½ unit; repeat at the top right. Join 4 to 6, 6 to 1, 1 to 7, and 7 to 5. Step off a ½ unit either side of the lines drawn. Using an adjustable set square project two parallel lines for each stroke to complete the letterform.

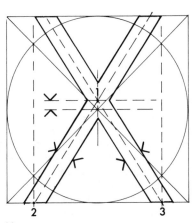

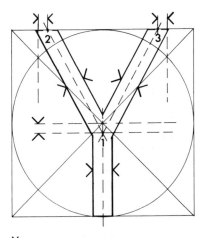

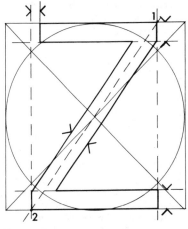

X

Draw a short vertical line up through the center and step off a ½ unit up to form 1. Project vertical lines from the intersections of the circle and diagonals, to form 2 and 3. Draw a diagonal line from 2 through 1 to the cap line and repeat for 3. Step off a ½ unit either side of the lines and project parallel diagonal lines using an adjustable set square.

Y

Project a line from the center to the base. Step off a ½ unit down from the center to form 1. Draw vertical lines from the intersections of the circle and diagonal lines to the cap line. Step off a ½ unit inwards from both lines to form 2 and 3. Join 2 to 1, and 3 to 1. Step off a ½ unit either side of the vertical center line. Project parallel vertical lines and diagonal lines to complete the letterform.

Z

Draw vertical lines from the intersections of the circle and diagonal lines to give 1 and 2. Join with a diagonal line. From the top left side of the line 2/3 step off a ½ unit inwards. Step off 1 unit down from the cap line and 1 unit up from the base line and draw horizontal lines. Step off a ½ unit either side of the diagonal line 1/2 and using an adjustable set square, project two diagonal parallel lines.

Sans serif: lower case letters 1

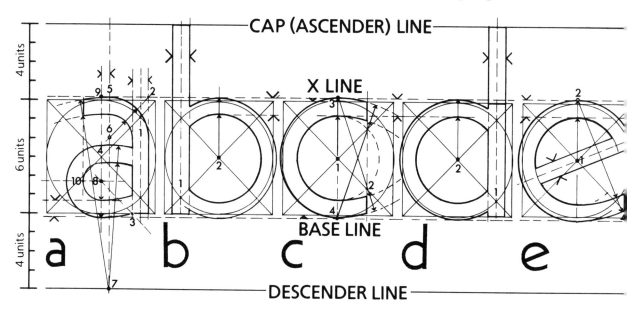

Grid for lower case Sans serif alphabet

Before you begin to construct the Sans serif lower case alphabet it will be necessary for you to draw a grid which contains 14 units, as illustrated above (see also page 32). You will observe that the new stroke width is ⅝ of the capital letter width.

a

Project a vertical line from the base, 1, and step off a ½ unit either side of the line. Draw vertical lines. Project lines at angles of 45° from 2 and 3 toward the center. Draw a vertical line through the center of the grid, 4. Step off a ½ unit to the right, 5. Project 5 to the descender line, 7. Step off 1 unit width up from the dotted compensation line at the base and project the horizontal line, 5. Using 6 as the center point scribe arcs to the vertical on the right. Taking 8 as the center point scribe semicircles to form the base of the letter a. Using 7 as the center point scribe arcs from the semicircles drawn to the vertical of the letter a; continue using 7 at the center point, open the compass up to the dotted compensation line, 5, and the upper arm of the letter a and scribe arcs to the left. Cut the arm to length by projecting a line from 10 vertically.

a (alternative)

An alternative letter a may be produced by following the instructions for the letter d, but omitting the ascender at the x line.

b

From 1 draw a vertical line from the base to cap line. Step off a ½ unit either side. Project parallel lines. At the top right, measure down 1 unit from the dotted compensation line and project a horizontal line to the left. Using 2 as the center point, scribe arcs.

c

From 1 project a vertical line from the base to x line. Measure down 1 unit from the top right of the grid at the dotted compensation line and project horizontally to the left. Using 1 as the center point scribe a semicircle for the outer curve and a circle for the inner curve. Where the circle intersects with the diagonal at 2, draw a vertical line which will terminate the arms. Using 3 as the center point scribe arcs to the right at the base. Repeat using 4 as the center point. Project arcs at the x line.

d

From 1 project a vertical line from the cap to base line. Step off a ½ unit either side and project parallel lines. At the top left of the grid, measure down 1 unit from the dotted compensation line and project a horizontal line to the right. Using 2 as the center point, scribe arcs.

e

Draw a vertical line through 1 from the base to x line. Step off 1 unit at the top left of the grid and project a horizontal line to the right. Using 1 as the center point, scribe arcs from the base to beyond 3. From 3 project a line through 1, step off a ½ unit either side and using an adjustable set square (triangle) project parallel lines. From 2 scribe arcs from the base toward 4. From 4 draw a short vertical line to cut the lower arcs of the letter e.

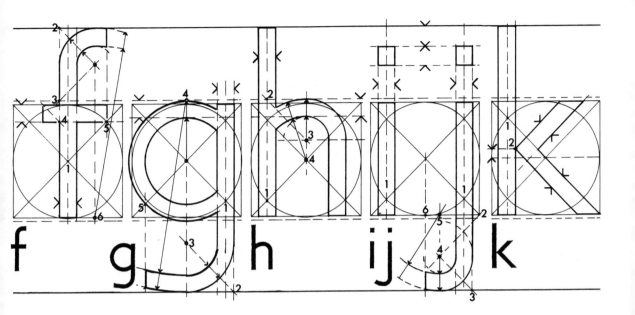

f
Draw a vertical line through 1 from the base to cap line, step off a ½ unit either side and draw parallel lines. From 2 draw a line at an angle of 45° down to the right. Repeat from 3 but in an upward direction. Using the intersection 7 as the center point draw a vertical line to the base then scribe two arcs as indicated. From 6 scribe 2 arcs as indicated. Draw a line at an angle of 45° up from 4 and to the left of the main stroke. Where this cuts the x line draw a vertical line. Draw a vertical line at 5 and continue to the cap line for the terminal of the arm.

g
Project a vertical line through the center from the x line to the descender line. Step off a ½ unit either side of this line and project two further parallel lines. Step off 1 unit on the top left of the grid and project a horizontal line to the right. Draw a line at an angle of 45° up from 2 to the left. From the center of the grid scribe two arcs to meet the vertical strokes at the top and bottom. From 3 scribe arcs to the descender line. From 4 scribe arcs as shown. From 5 draw a vertical line to cut the lower arm of the letter g.

h
From 1 draw a vertical line from the base to cap line, step off a ½ unit either side and project parallel lines. Step off 1 unit down from the dotted compensation line at the top right of the grid. Draw a line at an angle of 45° from 2 to intersect with a vertical line up from 4 to point 3. Project a horizontal line to the right. Using 3 as the center point scribe arcs to the right. Where the arcs intersect with horizontal line 3 to the right, draw two vertical lines. Using 4 as the center point scribe arcs to the left from the vertical line to meet the main stroke.

i
Draw a vertical line from 1 to the cap line. Step off a ½ unit either side and project parallel lines. To mark the position of the dot, measure 1 unit down from the cap line and 1 unit for the height of the dot.

j
Draw a vertical line from the descender line through 1 to the cap line. Step off a ½ unit either side and project vertical parallel lines. From 2 project a line at an angle of 45° to the left and down, and from 3 upward. Intersection 4 is the center point for the arcs. Project a vertical line from 4 up to the base line. Project a line from 6 to produce the cut off point of the lower arm of the letter j. Position the dot for the letter i.

k
Draw a vertical line from the base line through 1 to the cap line. Step off a ½ unit either side and project parallel lines. Draw a horizontal line from the center of the grid to the left edge. Step up a ½ unit from this and project a horizontal line to the right. From 2 draw a line at an angle of 45° up to the right and step off 1 unit. Repeat the procedure from 2, downward to the right. From each line project parallel lines.

l
Follow the instructions for the vertical stroke of the letter k.

©DIAGRAM

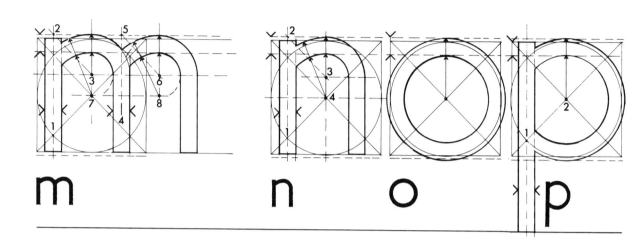

m n o p

m

Extend the dotted compensation line, x line, center line and base line to the right. Draw a vertical line from the base line through 1 to the x line, step off a ½ unit either side and project parallel lines. Step off 1 unit down from the compensaton line in the top left of the grid. Project the line to the right. From the center of the grid project up a vertical line. Draw a line from 2 towards the last line drawn and where they intersect, 3, project a horizontal line to the right. With the compass point on 3, scribe an arc to the right to touch the horizontal line through 3 and from the arcs draw vertical lines to the base. Using a unit gauge, mark the center between the uprights, 4, and project up to the dotted compensation line to 5. From 5 project a line at an angle of 45° to 6 and draw a vertical line from 6 to the dotted compensation line and down to the center line. Using 6 as the center point, scribe arcs to the right to touch the horizontal line 3/6 and drop two vertical lines to form the stroke. Project the center of the grid to the right. Using 7 as the center point scribe arcs to the vertical line 1/2. Repeat for the vertical line 4/5, using 8 as the center point.

n

Follow the instructions for the letter h but shorten the main vertical stroke.

o

Draw a vertical line from the center up to the dotted compensation line. Step off 1 unit from this dotted line down from the top left corner of the grid and project to the right. Using the center of the grid as the center point scribe two circles.

p

Follow the instructions for the letter b but lengthen the main stroke to the descender line. Cut at the x line.

q

Follow the instructions for the letter d but lengthen the main stroke to the descender line. Cut at the x line.

Useful tip

When scribing arcs, always start at the cap or base lines and work inwards. This avoids the problem of the arc not meeting the cross stroke.

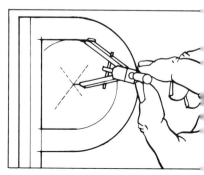

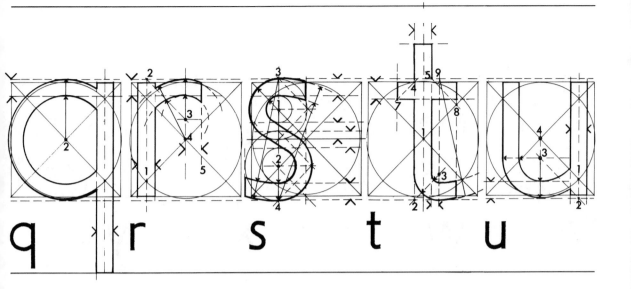

r

Project a vertical line from the base through 1 to 2. Step off a ½ unit either side and draw parallel lines. Draw a vertical line from 4 up to the dotted compensation line. Project a line at an angle of 45° from 2 towards 3. Step off 1 unit down from the dotted line and project a line to the right of the grid. Using 3 as the center point scribe two arcs. Using 4 as the center point scribe arcs to the main stroke. Step off 1 unit to the right of the center line of the grid and project a line upwards for the cut off point of the arm.

s

The general method of construction is virtually identical to the capital letter. However, note that both upper and lower circle center points, 1 and 2, are directly above each other on line 3/4. Stepping off units also change. The upper circle is stepped off down from the dotted compensation line and up from the center line. The lower circle, being larger, is stepped off a ½ unit above and below the center line. The arcs for the arms of the lower case letter also change, with 3 becoming the center point for the lower circle and 4 for the upper.

t

Draw a vertical line from the base line through 1 to the cap line. Step off a ½ unit either side and project vertical lines. Step off 1 unit at the top left of the grid and draw a horizontal line to the right. Step off a ½ unit at the base, right of the main stroke. Draw a vertical line. Project a line at an angle of 45° from 2. Scribe arcs from 3. Draw a line at an angle of 45° from 5 to 8; draw a vertical line at the intersection. Draw a line at an angle of 45° from 4 to 7 and a vertical line from 7. At the x line measure up 2 units for the terminal. Use 9 as the center point for the arcs at the base.

u

Draw a vertical line from the base through 1 to x height. Either side of the line step off a ½ unit and project vertical lines. From 2 project a line at an angle of 45° towards 3. From the center of the grid draw a vertical line to the dotted compensation line and draw a horizontal line through 3. Step off 1 unit at the base of the grid and project a horizontal line to the right. Using 3 as the center point scribe arcs from the dotted compensation line up to the line through 3 and project parallel lines from the arcs to x line. Using 4 as the center point, scribe arcs on the right to meet the vertical stroke of the letter u.

Accuracy hints

1 Make sure that your work is taped securely to the drawing board surface.
2 If using a tee square check that there is no movement between the blade and butt.
3 When projecting horizontal lines check that the butt is against the drawing board.

Sans serif: lower case letters 3

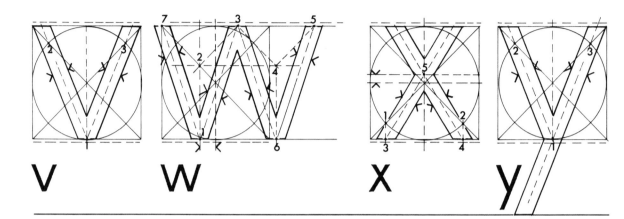

V W X y

v
From the center line draw a line to the base, 1. Project lines from 1 to 2 and 1 to 3. Either side of the diagonal lines step off a ½ unit and project parallel diagonal lines from the base to x line using an adjustable set square (triangle).

w
From the center of the grid draw a line to the base. Step off 1 unit to the left and project a vertical line to 2. From 2 project a line at an angle of 45° to the x line, 3. Draw a line at an angle of 45° from 3 to 4 and then from 4 to 5. Alter the adjustable set square to align with 6 and 5, turn the set square through 90° and draw a line from 6 to 3. Turn again and project a line from 3 to 1 and finally from 1 to 7. Either side of the lines, step off a ½ unit and project parallel lines to form the letter w.

x
Draw a vertical line from the x line through the center of the grid to the base. Draw vertical lines from 1 to the base and 2 to the base. Step off a ½ unit above the center and project a horizontal line. Draw a line from 3 through 5 to x line. Repeat from 4 through 5 to x line. Either side of the lines step off a ½ unit and project lines with an adustable set square to the x line.

y
Follow the instructions for the letter v, but lengthen stroke 3/1 to the descender line.

z
Project lines from the x line through 1 to the base, repeat through 2 to the base. From 3 project a line to 4, step off a ½ unit either side and draw parallel lines using an adjustable set square. Step off 1 unit down from the x line and up from the base line. Project horizontal lines. From 4 draw a line at an angle of 45° towards the center of the grid. Where this cuts the x line, draw a vertical line.

&
For the ampersand ("and" sign), first draw in above the cap line (ascender line) ⅙ of a unit, as a dotted compensation line. Draw a vertical line through the center of the grid from the base to 1. Project a line at an angle of 45° down from 1 to the right and up from 2 to intersect. Draw a horizontal line to the left to give 3, the center of the upper circle. Step off 1 unit down from the upper compensation line and from the lower compensation line below the base. Project parallel lines towards the center. Using 3 as the center point, scribe circles. Using the center of the grid scribe the lower circles. Project a line at an angle of 45° from 3 to 5. Join 5 to 4 and follow the line through to the base. Using an adjustable set square set to the angle formed by line 5/4, project a further line to the base to give the stroke thickness. Extend the base line to the right and draw a line from 6 to 7; project a further line for the thickness of the stroke. Using 8 as the center point, scribe arcs from the base to the right. Draw a horizontal line from 4.

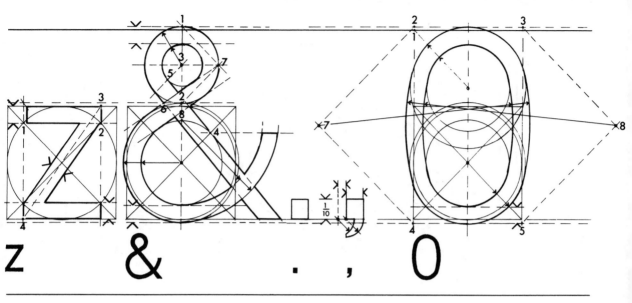

z & . , 0

Comma and full stop (period)

Step off ⅒ of the cap height from the base line. Step off 1 unit (lower case) wide, then a further ½ unit. Use the base left hand corner as the center point and scribe an arc; use a ½ unit mark to the left as the center point and scribe an arc.

1 Lining numerals
2 Hanging numerals

0

Draw vertical lines from the left, center and right of the grid from the base to cap compensation lines. Step up 1 unit from the base dotted compensation line. To find the center of the upper circle project a diagonal line, 1 to the center. Scribe the lower outer circle using the center point of the grid, and with the compass still set scribe the upper outer circle. Repeat the procedure for the inner circles. To find the centers for the outer arcs, project lines at an angle of 45° from 2 to 7, 4 to 7, 3 to 8 and 5 to 8, and project the arcs as indicated.

Numerals

There are two types of numerals – lining numerals and hanging or old style numerals.

Lining numerals

Lining numerals sit on the base line and invariably extend upwards to the capital line, or in some styles fractionally below.

Hanging numerals

Hanging numerals are placed in one of three positions on the grid. the numbers 1, 2 and 0 sit within the x height area. The numbers 3, 4, 5, 7 and 9 are treated like a lower case g, with part of the numeral within the x height and part extending as a descender into the descender area. The numbers 6 and 8 sit on the base line and project through the x line and into the ascender area.

Optional lining or hanging numerals

Some serifed letter styles or typefaces have optional lining or hanging numerals. This allows the designer or lettering artist to choose the preferred style. Lining numerals look best with capital letters and hanging numerals are more sympathetic when used with upper and lower case. Sans serif alphabets use lining numerals in the main although a few styles have both.

1 1234567890

1234567890

2 1234567890

1234567890

Sans serif: numerals

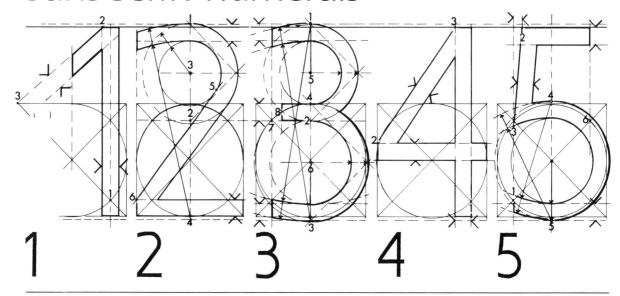

1 2 3 4 5

1

From the base draw a vertical line through 1 to the cap line. Step off a ½ unit either side and project vertical parallel lines. From 2 draw a diagonal line to 3 and, stepping off 1 unit, with an adjustable set square project a further diagonal line parallel to the first. Draw a vertical line from the center of the grid as the terminal position of the diagonal stroke.

2

Draw a vertical line from the base through the center of the grid to the compensation line above the cap line, 1; from 1 project a line at an angle of 45° down to the right. Step off 1 unit down from the dotted cap compensation line and 1 unit up from the base line; project horizontal lines. From 2 draw a line at an angle of 45° up to the right. Where the intersection occurs, project a horizontal line to cut the center line. Using 3 as the center point scribe arcs. Using 4 as the center point scribe arcs for the upper arms. From 6 draw a diagonal line to form a tangent with 5; project a further diagonal line using an adjustable set square. Cut the upper arm at the left side of the grid.

3

Step off 1 unit down from the dotted compensation line above the cap line, x line and up from the dotted compensation line below the base line; project all three lines horizontally. From 1 draw a line at an angle of 45° down to the right; repeat the procedure from 4. Draw a line at an angle of 45° up from 3 and then 2; where the diagonal lines intersect, project horizontal lines to cut the center. Scribe upper circles using 5 as the center point. Scribe lower circles using 6 as the center point. Using 3 as the center point scribe arcs for the upper arm and using 1 as center point scribe arcs for the lower arm. From 7 project a vertical line to cut the upper and lower arms. Where the circles intersect at 8, draw a short vertical line for the middle arm and project short horizontal lines to the right.

4

From 1 draw a vertical line from the base to the cap line. Step off 1 unit to the left of 1 and draw a vertical line. Project a horizontal line through the center of the grid and step up 1 unit; project a horizontal line. Join 2 to 3 with a diagonal line and step off 1 unit inwards projecting a parallel diagonal line.

Task
Styles
Look through your typeface collection in your scrap book and establish which styles have both hanging and lining numerals. If you don't have examples of lining and hanging numerals, search through library typeface books and dry transfer catalogues and take photocopies to paste into your typeface collection.

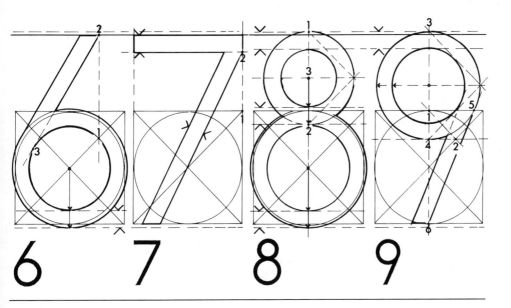

5
Draw a vertical line from the base through 1 to the cap line. Step off a ½ unit to the right. Step off 1 unit down from the cap line and 1 unit up from the base compensation line. Using the center point of the grid scribe circles. Project a vertical line through the center of the grid from the base compensation line to the cap dotted compensation line. From 2 draw a diagonal line to 3; step off 1 unit and project a further diagonal with an adjustable set square. Using 4 as the center point scribe arcs at the base. Using 5 as the center point scribe arcs at x line. Project a vertical line from 6 to give the terminal point of the cross stroke.

6
Step off 1 unit up from the base compensation line. Scribe circles. Project a vertical line from 1 to the cap line 2. From 2 draw a diagonal line to form a tangent with the inner circle, 3. Using an adjustable set square, project a further diagonal line to give the stroke thickness.

7
Extend the right side of the grid vertically to cap line 1 and repeat with the left side. Project a horizontal line. Step down 1 unit from the cap line. Draw a diagonal line from 2 through the center of the grid to the base line. Step off 1 unit and project a line to give the stroke thickness.

8
Draw a vertical line from the cap to the base through the center of the grid. Step off 1 unit down from the cap compensation line; 1 unit down from x height dotted line; and 1 unit up from the base dotted line. Project horizontal lines. From 1 draw a line at an angle of 45° down and to the right; from 2 draw a line at an angle of 45° up to intersect. From the intersection project a horizontal line to cut the vertical line. Using the center of the grid scribe the lower circles. Using 3 as the center point scribe the upper circles.

9
Draw a vertical line through the center of the grid from the base to cap line. Step off 1 unit down from the cap compensation line. Draw a line at an angle of 45° down from the center line, 1, to cut the diagonal line, 2, and project to the left to cut the center line, 4. Project a line at an angle of 45° down from 3 to the right, and up from 4 to intersect. At the intersection draw a horizontal line to the left to cut the center line. Scribe circles. Project a diagonal line from 5 to 6 using an adjustable set square and, moving the square to form a tangent with the inner circle, project a parallel diagonal line.

Sans serif: repetitious forms

You may have noticed when constructing your letterforms that certain shapes within the capital and lower case alphabets are repeated. Letterforms can be grouped by shape or ease of drawing. Some letters have the same construction details and can therefore be superimposed to eliminate extra work. Furthermore, an understanding of the way in which letterforms are repeated will assist you in generating new alphabet styles.

After carefully analyzing an alphabet style it is possible to group together those letters which may be generated on the same grid.

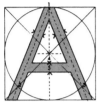 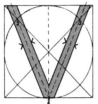 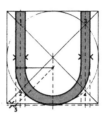 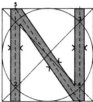

Capital letter groups
A, H, I, N, U and V are similar forms in width but not in shape. When overlapped, the forms can still be seen. Once the letter A has been drawn, the letter V can be taken from it by inverting the letter and omitting the cross bar. The letter H has been drawn on the same grid, not because it has a similar shape but simply to use the available area on the grid. The letters U and N are identical in width to the letter H and therefore have been superimposed to save work. The I can be taken from any vertical sided letterform.

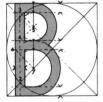 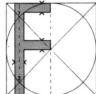 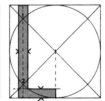 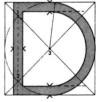

The cross stroke in the letter B is in the same position as the letter E. By deleting the lower cross stroke the letter F is generated. By deleting the two upper arms, but retaining the lower cross stroke, the letter L is created. A curve has been added to the vertical and upper and lower cross strokes to form the letter D.

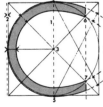 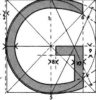

The letters C, G, O and Q can be generated from the same drawing. The letter D does not fall into this group because it has flat cross strokes at the capital and base line.

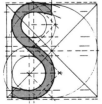 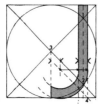 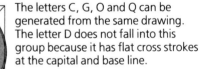 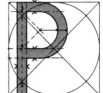 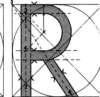

The letters S and J (*left*) are grouped together because their lower arches are identical. If you add a leg or tail to the letter P it becomes a letter R (*right*).

The remaining letterforms, K, M, T, W, X, Y and Z, require drawing separately. The letter M cannot be inverted to form a letter W because their shapes are very different.

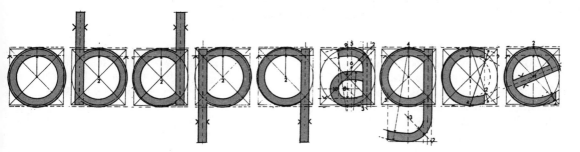

Lower case letter groups

The lower case alphabet also has much repetition. All the round letters can be generated on one grid by adapting, ie inverting, mirror imaging or adding or subtracting strokes.

Once the letter b is drawn it can be mirror imaged to form a letter d. If both the letters b and d are inverted they form the letters p and q respectively. By omitting the ascender from the letter d at the x line, the

letter a is generated. By making a few additions to the letter a the letter g can be produced. The letters c and e can also be worked on the same grid.

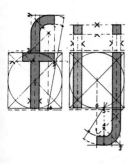

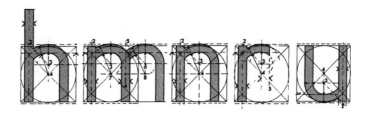

The letter f when mirror imaged and inverted will form the the basis of the letter j.

The letters h, m, n, r and u may be drawn on the same grid because they are of similar width or have similar construction details.

All of the remaining letterforms, k, s, w, x and z require drawing separately.

Task
Mirror images
Draw the letter b on tracing paper over a grid. Mirror image and invert it to see which letters can be generated.

Task
Comparison of forms
Trace the capital letter C from your alphabet sheet. Overlay the letter C onto the other round capital letters and note the similarities. Work through each of the groups above and make notes of your findings in your scrap book.

Numerals
There are similarities between the numerals 2, 3, 5, 6 and 8. It might not be apparent at first glance but some of the curves are generated from the same points. The remainder of the numerals require drawing separately. The number 9 for instance is not six inverted because the bowls differ in size. The numbers 1, 4 and 7 may be grouped. It is simpler to draw the zero separately because of its many curves and construction details.

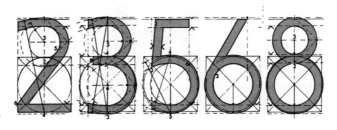

Inking in your alphabet

When you have constructed your sans serif alphabet you may then wish to ink it in. The techniques used when inking in on tracing paper are slightly different from those used when inking in on stiff paper. If your alphabet is constructed on tracing paper it is inadvisable to use a brush with india ink to fill in the strokes as the tracing paper buckles or cockles when wet.

Tools and materials
You will need the following:
1 A technical pen, with compass attachment, or a ruling pen and compass ruling pen attachment.
2 A waterproof fiber pen for filling in the strokes.
3 A scalpel holder (or X-Acto knife) and blades for correcting.

Curved lines
Using either your compass and technical pen or ink compass, scribe all the circles and arcs throughout the alphabet. This will save time and negate cleaning of the ink compass (if used) after each letter. Once all the circles and arcs have been drawn in ink, repeat the exercise but this time reduce or increase the circles/arcs to thicken the lines slightly. Remember to always thicken on the inner side of the line working inwards to the stroke, not outwards, as this will distort the letterforms.

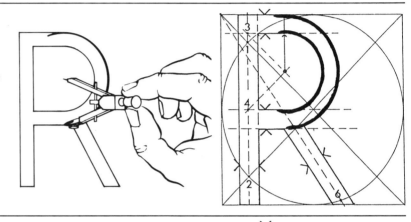

Straight lines
Once this is completed, draw over the straight lines in ink, again thickening the lines to the inside of the stroke.

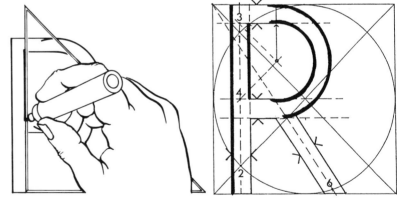

Filling in
When all the letterforms have been outlined, take a medium point fiber tip pen and fill in the insides of the letters.

Useful tip
When inking in letterforms and using set squares and rulers as straight edges, stick masking tape to the underside of the rule/set square a little way in from the edge. This prevents the ink from seeping underneath the edge.

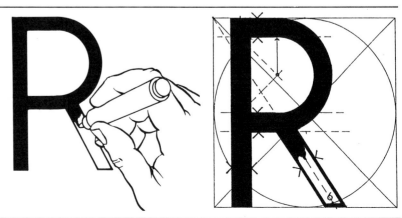

Cleaning away mishaps

However much care you take in inking in letterforms, mishaps do occur; ink blots, overrunning a line, and smudging your work all can appear disastrous. You can clean away ink from tracing paper using a scalpel blade.

Gently scrape away the ink using a 10a (or X-Acto no. 11) blade flat to the surface. The movement should be in more than one direction working into the offending area. In this way not only is the ink removed but also a layer of tracing paper without leaving a sharp ridge. Once the error has been removed, burnish the paper by rubbing the area with a finger nail. This flattens the fibers so that when the surface is reworked the ink doesn't feather or bleed.

Build up a store of master alphabet sheets

When you have finished inking in your alphabet you may find it useful to store this safely in order that you may use it in any future projects you undertake. Once you have become proficient at freehand drawing and letter and word spacing, the alphabet you have produced makes a good reference for over tracing.

When a sign or poster is required quickly, the alphabet sheet is used as the master and the letterforms are traced directly from the sheet. Master alphabet sheets are more durable if lettered on stiff paper. It is useful to have several sizes of each alphabet to give a choice of letter height when producing signs or posters. The master alphabets can be drawn separately to different heights, or alternatively, a photocopying machine which has the facility to enlarge or reduce the original can be used.

Task

Drawing a letter P

Draw up a letter P on tracing paper in 2H pencil, outline with your technical pen and fill in the center with a fiber tipped pen. Continue with other letters of the alphabet until you feel that you are proficient.

ABCDEFGH
IJKLMNOP
QR
XYZ
abc

ABCD
EFGHIJ
KLMN

© DIAGRAM

Roman alphabet 1

The classic forms of the Roman capital alphabet are the basis of many designs and have been used for over the past 2000 years. Originally produced as carved forms their beauty is now part of our cultural heritage. Because the letters are highly sophisticated forms that do not lend themselves to direct mathematical construction, they are best drawn freehand using a grid as a guide to their shapes.

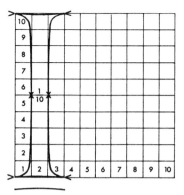

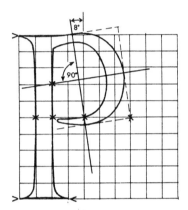

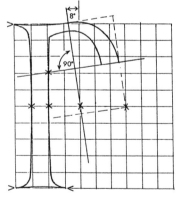

An example of a Roman vertical and round stroke letterform
The letter P is illustrated above. To create the letter, reference points have been gained by examining the form on its grid. Where necessary, lines are projected to assist in the construction. The dotted area shows half of the rectangle in which the curved strokes are constructed, with the upper quarter being drawn first and the lower portion being generated by inverting the upper quarter.

Tools and materials
To construct this alphabet you will require the following tools and materials:
1 A drawing board.
2 A tee square (or parallel motion).
3 An adjustable set square (triangle).
4 A ruler.
5 HB and 2H pencils.
6 An eraser.
7 Masking tape.
8 Tracing paper.
9 A sheet of stiff paper.

Basic proportions for Roman capital letters
Before you start the classical Roman alphabet, study the proportions of the examples shown. This alphabet has been placed on a gridded square measuring 10 units high by 10 units wide. The stem of the main stroke is approximately $1/10$ of the cap height. However, the main stroke splays outwards from this width, which is centralized on the height. The horizontal stroke is approximately half the main stroke width at its thickest point. The maximum point of stress on all round letterforms is at 90° to the angle of inclination, which is 8° from the vertical. As with all round strokes the weight is slightly heavier for optical adjustment. The letterforms should be freely drawn on the grid first in HB pencil and firmed up with a sharp 2H or 4H pencil, rubbing out areas as they are corrected.

The Roman capital I
In the above illustration the capital letter I is placed on the grid. Note the reference points with arrows. The letterform is 3 units wide if we include the bracketed serifs. The stroke width of the character measures $1/10$ of the height (1 unit). The line at the head and foot of the letter is curved (not flat) so you can still see the capital and base lines; this is a trait of the style and all the characters ending with a similar serif are treated in this way. Study the main stroke and you will see that the lines are not parallel, but from the $1/10$ unit splay out upwards to the capital line and downwards to the base line. This again is a characteristic of the style. There are no parallel or straight lines in the alphabet as they all taper and splay. The letter I forms the criterion for all the vertical stroke letters, diagonal and secondary (cross) strokes, regardless of thickness.

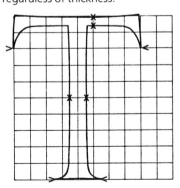

The Roman capital letter T
The letter T is formed from the letter I with a cross stroke of $1/2$ unit width added at the capital line. This cross stroke has a bracketed serif at each end and is not a straight line but a gentle curve. The cap line is just visible in the center of the stroke.

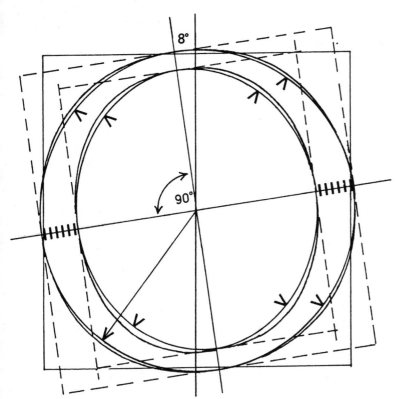

The Roman capital letter O

The above illustration shows the letter O placed on the grid. The shape of the O forms the criteria for all round letters. It has stress, ie the letter shape is not vertical but leans to the left. The angle of stress is 8° from the vertical. The shading, ie the widest part of the curve is at 90° to the stress and marginally wider than the 1/10 width. The thin stroke is about a 1/2 unit in thickness. The classical Roman alphabet can be described as having diagonal stress with oblique shading for its round characters.

To show the shape, the letter O has been superimposed onto geometric shapes – an outer circle and an inner ellipse. You will see that the letter O conforms to neither the inner nor the outer shape. The letter O (like the letter I) has no geometric form in that it is a freely drawn shape.

Examples of errors sometimes made when drawing the Roman capital letter O

The illustration (*top right*) shows a letter O which is too wide. The original quarter section was not drawn accurately in width and when the image was overworked (ie maneuvered to give inverted and mirrored images) to generate a full letter O, the error was compounded. In the illustration (*second right*) the first quarter of the letter O has been drawn inaccurately, producing a pointed effect at the axis. The curve should have been fuller in shape and at right angles to the axis at the point of intersection.

In the illustration (*third right*) the true form of the letter O has been highlighted to show the degree of error in the above two drawings.

Practice makes perfect

From the examples you can see how important it is to draw the first quarter of the letter O correctly. You may find that you need to make several attempts before the final shape is correct, but it is well worth the effort because other characters are generated from this shape. Remember that all round letters, except for the capital and lower case letter S, have a stress of 8° from the vertical. Round letters also break the grid lines and should be drawn to a compensation line to allow for optical adjustment.

Roman alphabet 2

The remaining letters of the Roman capital alphabet are shown opposite. There was considerable interest during the Renaissance in the Roman capital alphabet. Artists reconstructed letterforms using rulers, straightedges and compasses and there was much discussion on the proper ratios of letterforms.

Letterforms based on the work of Renaissance artists

Fra Luca de Pacioli used the compass as much as possible in constructing his alphabet, which was published in 1509.

Albrecht Dürer's constructed alphabet was published in 1525 in Nuremberg. Dürer's models show slightly more reliance on freehand drawing and less reliance on the compass.

Geoffroy Tory's alphabet was published in 1529. He considered that capital letters should be fashioned after the three most perfect figures of geometry – the circle, the square and the triangle.

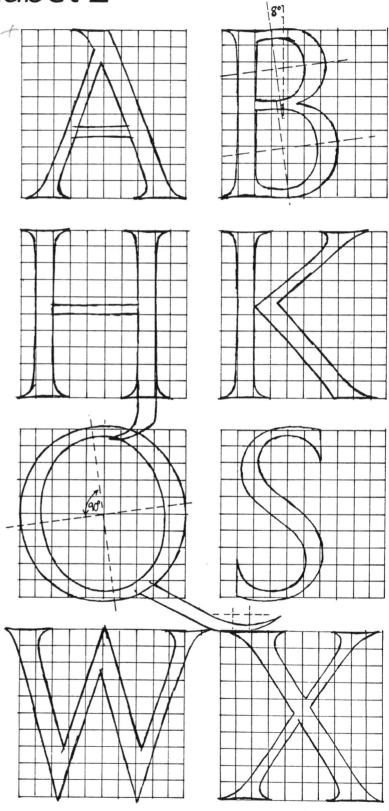

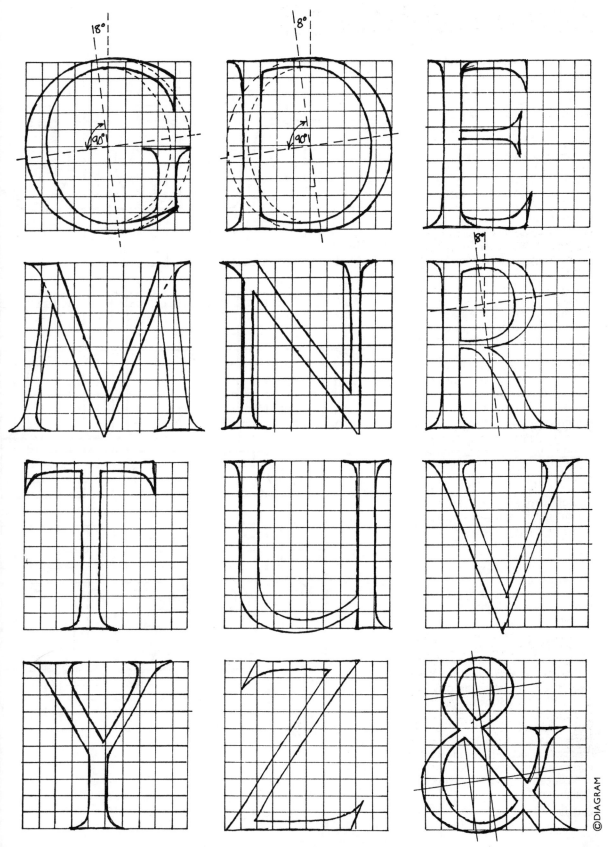

Roman alphabet 3

Basic proportions of classical Roman lower case letters

The grid on which the lower case letters are drawn is 14 units in height. It is only extended by 4 units from the base line downwards to accommodate the descending letters (the descender area). In this style there are 10 units from the base line to the capital line (ascending line). However, these units are subdivided to give two separate areas, the x height and the ascender area. The x height measures 6 units from the base line up to the x line and the ascender area takes up the remaining 4 units.

Stress

The angle of stress for the lower case letters remains at 8° from the vertical. All rounded letterforms have this stress. When you begin to construct letterforms it is advisable to start with the letter O as this shape, or variants of it, are repeated frequently.

Round strokes

The width of the main stroke on a round form is marginally more than 1/10 of a unit but not as wide as the capitals.

Straight strokes

The straight main strokes are drawn to approximately 1/10 of a unit. They do not splay out as much as their capital counterparts.

Thin strokes

The thin strokes of both round and straight letters are slightly less than half of 1/10 of a unit.

Cross strokes

The cross strokes on the letters f and t are slightly below the x line. The lower case letter z cross strokes dip only in the center of each stroke.

Serifs and feet

The serifs and feet, whether horizontal or inclined, are drawn with a slight concave curve to them. As with the capitals, there are no true straight lines.

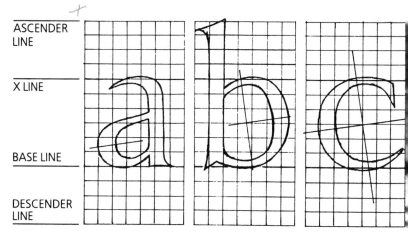

ASCENDER LINE

X LINE

BASE LINE

DESCENDER LINE

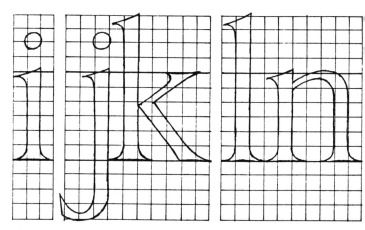

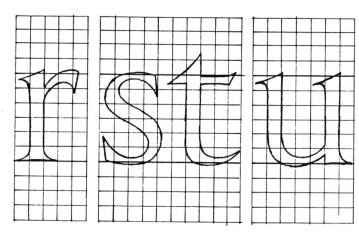

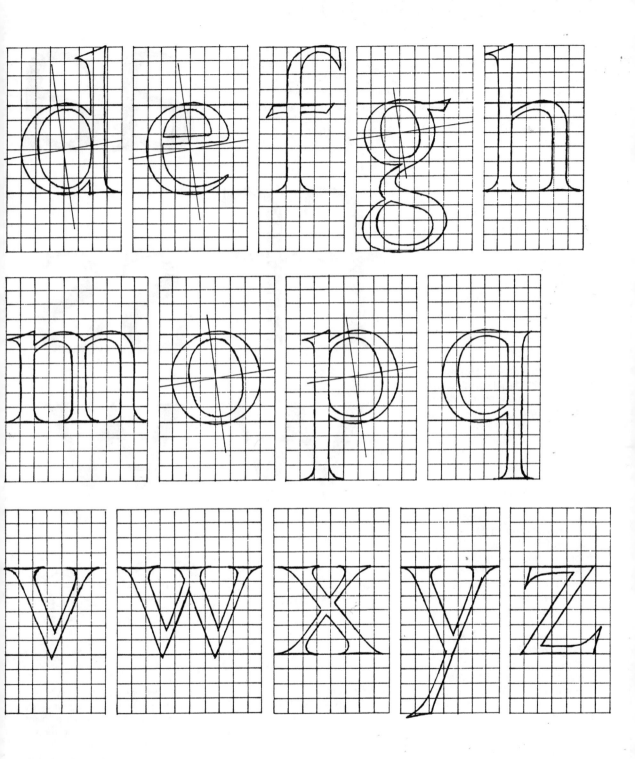

Repetition

It is much more difficult to mirror image and invert shapes in the Roman style than in the Sans serif style. The p and q, for instance, are slightly different. When examining the letter m you can see that the counters are somewhat narrower than those of the letters h or n.

Roman alphabet 4

Alternatives

Two styles of the letter w have been produced. The original version consists of two overlapping leter v's while the modern form has a pointed middle apex. It is perhaps worth noting that this alternative style may be used in the capital alphabet. Here are two alternative terminals and serifs for the letters a, s and f. Whichever style is chosen it is important to use the same endings consistently in order to produce a harmonious effect.

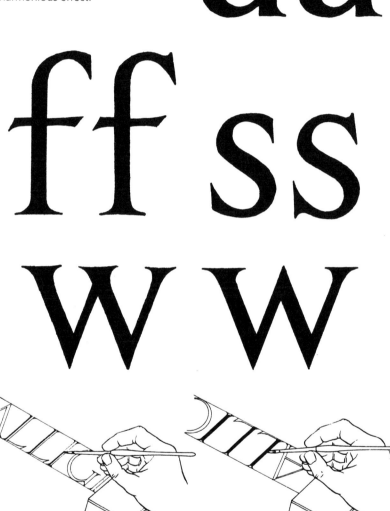

Inking in on paper and board

If you have drawn your letters directly on to stiff paper or board you may ink them in with a brush.

Tools and materials

You will need the following:
1 An artist's sable no. 3 pointed brush.
2 India ink (non waterproof).
3 A home-made bridge.

Starting with vertical strokes

Load the pointed sable brush with ink, removing excess on the edge of your bottle by turning while wiping. Position your bridge for painting in a left hand vertical stroke. Ink in the vertical stroke resting your painting hand on the bridge while supporting the bridge with your free hand. Look directly over the line being lettered to monitor the progress of the brush. Start at the base of the letter and work upwards ending the stroke a little way from the cap line (see diagram 1). Move on to the next left hand vertical stroke and repeat the procedure. All the left hand vertical strokes in the word should be lettered before moving onto the other parts of the letterforms. This method of painting reduces the time taken in positioning the bridge for individual strokes.

The work should now be turned upside down so that the right hand sides of the letterforms can be inked in (see diagram 2).

Diagonal strokes

Once the word has all of its vertical strokes painted in, the bridge can be moved into a position suitable for diagonal strokes. Ink in these strokes following the same procedure as for vertical strokes.

Cross strokes

All cross strokes should be inked in next. Paint one side then turn the work over and paint in the other side (see diagram 3).

Round strokes

Paint the outer edges of round strokes first (see diagram 4). The bridge can be repositioned as each portion of the curve is completed.

You may have to reposition yourself a number of times around your work surface to complete the letterforms. Once the outer curve of a letter is finished, the inside curve can be painted. If the work is not too large, the work piece itself can be turned. It is important not to rest your hand directly on the work, as grease from your hand will transfer to the work surface and ink will not take to it. If

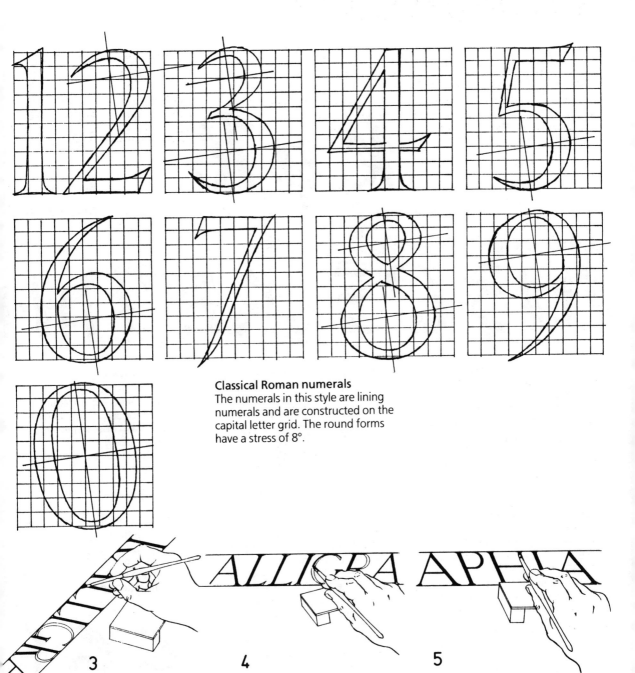

Classical Roman numerals
The numerals in this style are lining numerals and are constructed on the capital letter grid. The round forms have a stress of 8°.

3

4

5

the work is to be turned, it is difficult to use a bridge. Protect the work surface with a piece of card under your hand.

Serifs
The serifs should be painted in last. Work in from the point of the serif to the main stem (*see diagram 5*).

Retouching
If any areas require retouching, opaque white paint for white backgrounds or a mixed designer color for colored papers may be used. When retouching, it is important not to allow the india ink to become too wet as it may bleed into the retouching paint.

Task
Inking in with a brush
Choose some letters to draw up on stiff paper and follow the instructions for inking in with a brush.

© DIAGRAM

61

Brush script 1

Brush script is a very versatile method of producing quick professional quality lettering. It is ideal for those urgent notices, posters and display cards.

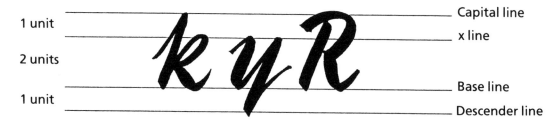

1 unit	Capital line
	x line
2 units	
	Base line
1 unit	Descender line

Basic brush directions of practice strokes

Setting up a work surface
You will need to set up a drawing board. An adjustable one is useful as the angle of the work surface can be changed to suit. If you don't have one, a board leaned against a table top and resting on your lap is fine. The angle should be approximately 30° to the horizontal.
It is important to be comfortably seated when practicing brush script. The position of the head and eyes in relation to the work is also important. The line to be lettered should fall slightly below eye level. The working surface should be kept clear of inks, paints, water jar and other equipment.

Task
Drawing grid lines
Tape a sheet of stiff paper to your board and draw a series of grid lines on the sheet with the cap to base line measuring ¾" (30 mm).

Method of lettering in brushscript
Grid lines are drawn with an HB pencil for the capital line, x line, base line and descender line. The lines are positioned just below eye level when you are in a seated position.
Load the brush with ink or paint by first dipping the hair in the pigment, and then wipe the brush on the side of the bottle or pallet while turning the brush. If there is too much liquid remaining on the brush, the ink or paint will run, while if there is too little the brush may run out of ink or paint before the stroke is finished. Lay the tip of the brush on the paper at an approximate angle of 30° to the writing line. The degree of pressure applied governs the weight of the stroke produced. Italic letters have an inclination of about 20° to 25° from the vertical. The starting point for most strokes in the capital alphabet is at the capital line.

Size of letters
The thickness of the stroke is determined partly by the size of the brush used and partly by the pressure applied. A no. 3 long haired sable brush has been used to produce the illustration of the letter S (*right*).

Basic movements
The strokes illustrated above are the basic movements, which require mastering, for both capital and lower case letters. On close inspection you can see that nearly all the characters in the alphabet can be made up from these strokes.
The style is built up from positive deliberate movements and is best achieved when the strokes are completed in one movement. If you hesitate slightly in the middle of a stroke the positive action is lost. The movement emanates from the shoulder and wrist depending on the size of the letterforms.

Proportions of letterforms in brush script (*left*)

The proportions of the letterforms, ie x height to ascenders and descenders is usually 2:1. This ratio can, however, be modified to suit the requirements of the work in hand.

Tools and materials

To produce this versatile freehand style you will need the following tools and materials:

1 An adjustable drawing board or sloped drawing board and tee square.
2 A set square (triangle).
3 A ruler.
4 A good quality long haired no. 3 sable brush.
5 Non waterproof ink or gouache.
6 A pallet.
7 A jar of water.
8 Stiff paper.
9 An HB pencil.
10 Masking tape.

Even pressure

Uneven pressure

Straight strokes

Holding the brush at an angle of 30° from the capital line, move it down towards the base line. Speed is of the essence and this movement should be done quickly to give character to the letterforms. If the stroke is lettered too slowly the form will not be so clean and the result will be uneven.

Task

Practicing brush strokes

Take your no. 3 brush and ink or paint (mixed to the consistency of light cream) and practice the strokes.

Brush action

The action of the brush is important and a good sable brush has spring, which assists in the construction of the forms when pressure is applied and released to give the thick and thin strokes. Use the little finger to lift the hand, while bending the thumb and index fingers to lift the brush away from the writing surface.

Task

Examining strokes

Examine the direction of the practice strokes and the weight of each stroke. Take special note of the curved forms, the point at which pressure is the greatest when the stroke is at its thickest and the point at which the pressure is the least when the stroke is at its thinnest.

Pressure

The pressure on the brush hair governs the stroke width and therefore must be kept constant. The result of uneven pressure is an erratic letter with irregular sides.

On curved strokes, the pressure is light at the start of the stroke and steadily increases until a weight of stroke is achieved which is compatible with the straight letterforms. The pressure is then gradually eased off to thin the stroke again. This laying on and easing off of pressure can be seen clearly in the practice stroke which forms the left side of the C, G, O and Q. It is essential to master this before attempting the Sans serif alphabet.

Compare the examples of the brush strokes (*center left*) in which the pressure is even, with those (*center right*) in which the pressure is uneven.

Brush script 2

Once the basic strokes have been mastered the alphabets shown below can be approached with confidence. Follow the order and direction of the strokes indicated, taking note that some of the strokes end on an upward movement. The thickness and thinness will depend upon your brush and the pressure you apply. The style will be the result of your handwriting characteristics.

Variety
The selection of examples (*right*) show how the simple forms of a brush script in the hands of a practicing lettering artist take on different features. Not only are they individually different, but national characteristics affect them because of differing educational and cultural influences.

ABCDEFGHIJKLMNOP

QRSTUVWXYZ 12345

67890£?!&OQabcdef

ghijklmnopqrstuvwxyz

abcd *aabcd* *abcde*
ABC *ABCD* *ABCD*

Examples (*left*) of a Sans serif style alphabet, upper and lower case, produced using a long haired sable brush.

Capital alphabet (*right*) produced using a square ended brush.

Task
Try different brushes
Draw out the alphabet between two lines with your usual brush. Then redraw the letters using either a larger or smaller sized brush.

Task
Try different size letterforms
With your usual brush try drawing your script style in either a larger or smaller size.

Task
Try to build up speed
Draw out a row of letters of the alphabet evenly and carefully, taking as much time as you need. Repeat the row of letters several times, building up speed as you practice.

©DIAGRAM

ABCDEFGHIJKLM

ABCDEFGHIJKLM

ABCDEFGHIJKLMN

A B C D E F G H I J K L M

ABCDEFGHIJKLMN

APPLICATION

This chapter is concerned with the application of letterforms and how to use the alphabets that you have constructed.

There are numerous ways in which letterforms are used to communicate. They are employed to convey information, as on handbills, posters and signs. Letterforms often play a decorative role on murals, house signs, sail boards, boats, skateboards or T shirts where the forms are an embellishment. Fairground letterforms are a wonderful example of letters being used to project a fun, larger than life atmosphere.

There are many ways of applying letterforms. They can be cut out of several different materials – card, paper, acrylic sheets, laminates, wood, metals or cloth and can even be baked as biscuits. Almost any material which can be formed by molding, or is capable of being cut out or incised into can be adopted. The forms can be conventionally painted by brush or spray painted using a mask or stencil. In the following pages we will look at the application of letterforms in creating stencils, painted signs and artwork for reproduction. When you have mastered these techniques you may wish to venture further into using the many materials available.

The essential part of any lettering method is the origination – the tracing from which the letterforms will be generated. The process of tracing and tracing down is explained in full, as many of the methods employed in producing letterforms require this process.

NOPQRSTUVWXYZ

NOPQRSTUVWXYZ

OPQRSTUVWXYZ

NOPQRSTUVWXYZ

OPQRSTUVWXYZ

Developing letterforms

Having mastered the basic proportions and construction techniques of letterform design, you can then develop the characteristics of letters in a variety of ways. Remember that whatever the inventive and interesting adaptations you devise , the prime purpose of any word is to be read. Avoid styles which are over elaborate and therefore hard to produce. It is better to achieve an excellent simple solution than a poorly produced elaborate one. Lettering artists have been developing their styles for over 5000 years and will continue to twist and distort the basic proportions, testing our powers of identification.

Ideally, any decorative style you introduce should reflect the character you wish to portray in the word. Inappropriate styles, such as flowery letterforms on a highway sign or nineteenth century forms for a computer company symbol, hinder rather than strengthen the message they are conveying.

Within the forms
The basic outline features of a style are retained but the surfaces are decorated or changed in some way to add interest.

Perimeter additions
The basic outline features of a style are retained but edges beyond the surfaces are decorated or changed in some way to add interest.

Special shadows
The basic features of a style are retained but their silhouette characteristics are repeated, usually in a lower position to imply that they are casting a dropped shadow of their forms. This method is very easy to produce as initial pencil tracings of the forms can be reused in a new position.

Three dimensional
The basic features are retained but the letters are extended in some way so as to indicate that they are constructed from solid material or incised into a surface.

Outline forms

The basic features of the letterforms are retained but the centers of the shapes are not filled in so that the letters appear in outline. This style is often very delicate and refined but is also very difficult to paint or draw with accuracy.

Distorted forms

Lettering artists often distort basic letterforms to produce a personalized and unique form. In this situation no rules apply as the letters are often the work of inspired invention.

Serifed forms

The ends of strokes of the letters can have a wide variety of embellishments. In traditional calligraphic styles these were quick twists of the pen after completing the stroke. In later styles the ends became a dominant feature of the forms.

Swash forms

These are extensions to letterform strokes. They are mainly used with styles that have serifs, although, brush script styles often have this type of adornment. There are a few Sans serif styles which adapt to swash extensions. In their true form, swashes are curved strokes ending in a curl, point or small ear.

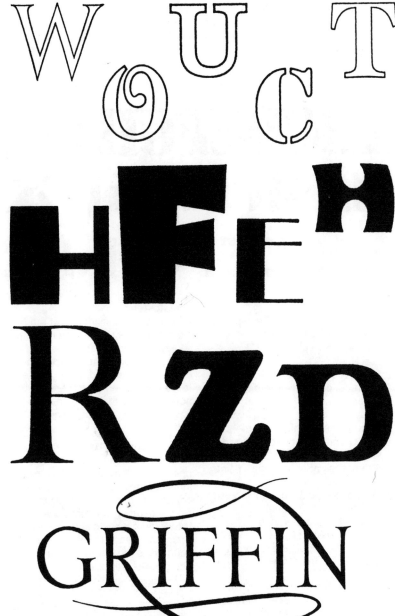

Task
Embellishing alphabets
Draw or photograph the many ways in which the word "Sale" may be embellished. Put the drawings or photographs in your scrap book for reference.

Task
Collect examples
Collect samples of embellished letterforms from packaging, newspapers and magazines. Take photographs of signs and vehicles. There is a wealth of reference in every main thoroughfare which you can record for future use.

Task
Embellishing sans serif and Roman letters
Take a word and letter it in both Sans serif and Roman. Work over your words on tracing paper and experiment with the various embellishing techniques.

Stencils

Stencil applied letters are a quick method of producing a sign or decorative image. The materials involved are easily obtainable and require little outlay.

Stencil alphabets
The alphabets which have been described in this book can be adjusted to allow for stenciling. However, specifically designed stencil letters may be obtained, as these examples show (*below*).

ABCDEFGHI abcdefghij ABCDEFGHIJKLMNOPQ

äcbcef ABCDE

Tools and materials
In addition to your general equipment you will need the following:
1 Cutting tools, either artists' knives or scalpels.
2 Sponges and flat-headed stencil brush, for dabbing ink into the surface.
3 Spray diffuser, for spraying inks through the stencil.
4 A tin of spray paint suitable for the surface to be worked on. Alternatively a suitable brush paint can be used.
5 For the more ambitious an airbrush is a useful tool. Although airbrushes, cannisters and compressors are expensive, they provide the opportunity to produce a range of different finishes to your work.
6 Some oiled paper/board or card.
7 Artists' self-adhesive clear film (such as that used to cover books).

A basic stencil
A basic stencil is an image cut out of a piece of card or similar material. The chosen medium is passed through the open stencil on to the surface to be decorated or lettered. The material for stencil making must therefore be non-porous so that the medium only passes through the cut out areas.

Adjustment to letters
Because the area to be applied is an open shape, letterforms which have inner counters require some adjustment to prevent the counter from separating and moving while the medium is being applied. Ties are therefore needed to link the inner counters to the surrounding areas and give the stencil stability.

Making a basic stencil (*right*)
1 Trace down the required image onto the oiled paper or board. If you are using ordinary card trace the image down and then cover both sides of the card with a sheet of self adhesive clear film. This will prolong the life of the stencil if more than one application is required.
2 Cut out the letterforms, remembering that all inner counters require a tie with the surrounding counter of the letterform.
3 Place the stencil onto the desired surface and, using a brush, paint or dab the image area until the required coverge is attained.

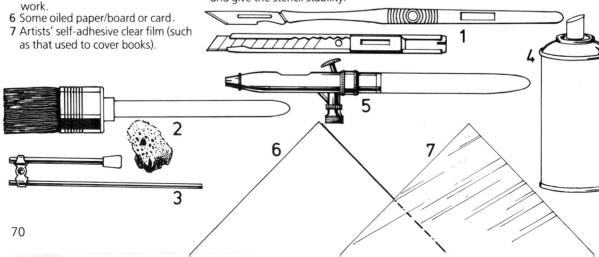

1

1

Using masking film to produce a stencil (*right*)

A stencil may be produced using masking film. This method gives a professional finish with clean edges to the letterforms. This is achieved because the stencil is adhered to the surface as opposed to merely resting on top. It is perhaps worth noting, however, that masking film can be applied only to smooth surfaces.

Advantages

The major advantage of producing stencils using masking film is that it permits greater choice of letterform style. There are few restrictions on the styles used because the inner counters adhere to the surface, eliminating the necessity for ties. It is ideal for producing images on surfaces such as laminates, glass, spray painted metal and painted or varnished wood.

Making a stencil using masking film

1 Trace down the image onto the required surface and cover with masking film.
2 Cut around the letterform with a scalpel.
3 Remove the letterforms which require painting (the image area) by first lifting the corner of a letter and then peeling away the form. Take great care in removing the letter to prevent the inner counters from becoming detached.
 The area surrounding the letterforms may require further masking if the letters are to be spray painted. If necessary use newspaper taped to the surface with masking tape.
4 The stencil may now be painted or sprayed. If using a spray paint, check that the board is in the vertical position and wear a face mask.
5 Remove the stencil while the paint is still tacky. If oil or acrylic is allowed to dry completely a skin is formed between the letter image and the edge of the stencil which can result in the letterform lifting away with the stencil.
 It is advisable to peel away small sections at a time. A scalpel may be used to separate a portion of stencil from the main area.

2

2

3

3

4

5

Artwork for reproduction

Lettering intended for reproduction by a printing process is produced in a similar fashion to forms lettered on paper or board. All lettering which is generated as artwork for subsequent printing is generally produced black on white. Before artwork can be printed it must first be photographed onto film. Some colours on artwork, for example red, will show up as black on the film whereas light yellows and blues will not register on the film at all. The lettering artist should be aware of this as it directly affects the preliminary stages of producing artwork.

If the artwork is required for a poster or handbill, then the work can be lettered in strips on line cut paper and assembled later. This is called a paste up.

Tools and materials
In addition to your usual equipment you will require the following:
1 Tracing paper for initial ideas and designs.
2 Line art board or paper.
3 India ink.
4 Light blue pencil or very light 2H or 4H pencil.
5 Rubber cement or an art adhesive spray.
6 Petroleum lighter fuel.

Paste up

Stages in producing a paste up
1 **Master artwork sheet**
 Mark in light blue ink or pencil the extremities of the project (sheet size to be printed).
2 **Tick marks**
 Place a tick mark (in black ink) at each corner of the frame; these are used as a guide for the printer when guillotining the finished printed work. Tick marks are also used to register each overlay into its exact position and should therefore also appear on the acetate overlays.

Artwork

Preliminary work
All of the preliminary work prior to lettering in black ink on a white surface should be produced in light blue pencil or a very light 2H or 4H pencil, otherwise these lines may be picked up on the film.

Useful tip
Clean equipment and hands are an important requirement. In order to reduce grease on hands and fingers, dust them in French chalk.

Stages in producing artwork
1 **Generating ideas**
 Work out your idea on tracing paper in pencil or fine fiber pen. Progress your ideas and experiment with different letterforms and layout. This initial design stage is a very important part of the production process.

2 **Size of artwork**
 Once you are satisfied with your design, decide on the size to draw the artwork. It should be drawn at least to the same size as the finished work is to appear, although it is usually drawn half as big again as the final version. The reduction of the artwork onto film reduces any minor deviations in stroke width which may be present in the original.

3 **The master drawing**
 You should now produce a more precise drawing of the designed lettering on tracing paper. This should be drawn to the enlarged artwork size. At this stage the letter and word spacing together with the positioning of the elements should be decided upon. The initial drawing should be produced with a sharp 2H or 4H pencil. If the lettering is of a complex nature it may be necessary to overwork the drawing on a further sheet of tracing paper. Quite often two or more drawings are made until the design is worked up to a satisfactory standard. This drawing is the master from which the artwork will ultimately be generated and therefore should be clean and accurate.

4 **Preparing the master for tracing down**
 The line art board or paper on which the artwork is to be lettered must now be cut to size and taped securely to the drawing board. Turn the master drawing over and work over the reverse of the tracing in HB pencil. Work the graphite into the tracing paper using a piece of paper towel or tissue. Remove any surplus or loose graphite before tracing down. It is advisable not to apply the HB pencil with the tracing resting on the line art board as the pencilled image of the lettering may transfer onto the line board.

5 **Tracing down**
 The tracing sheet should now be turned face up, placed on the art board or paper in the required position and taped securely top and bottom. Taking a hard pencil, 4H or 6H, trace the image over to offset the HB pencil onto the line art board. This should be done very carefully and accurately in order that a clean image is achieved on the board surface.

6 **Checking the image**
 Remove the tape from the bottom of the tracing paper only and lift to check that all of the image has been transferred.

3 Letter the text

Letter the text for the project on line art paper following the step by step procedure described. Once all the text is lettered, it can be cut into strips ready for pasting-up. Check that all pencil lines and graphite are removed before attempting to paste-up.

4 Inner border

Draw an inner border in light blue ink or pencil, leaving margins on all four edges of between ⅜" to ½" (9mm to 12mm). This gives room for the machine to grip the sheets of paper during printing.

5 Position the text

Position the work onto the artboard to check that the words fit into the width and depth of the frame.

6 Glue text into position

Apply rubber cement or an art adhesive spray to the reverse of the strips and position as paste-up. The main color of the design is positioned on the base artwork (on the paper or board) and acetate overlays are used for additional colors.

7 Check elements are square

Check that elements are pasted up square to the frame by using your parallel motion, tee square and set square or ruler and set square (triangle).

8 Remove excess glue

Remove all excess glue. Petroleum lighter fuel will remove the spray adhesive but be careful not to smudge the ink during cleaning.

9 Overlay with tracing paper

Once the work is completed, tape a protective overlay of tracing paper to the board as a cover.

7 Painting in

The style drawn will determine the drawing or painting in equipment to be used. If the letterforms have many straight lines then a technical pen can be used to draw these; a compass attachment may be used to draw arcs and circles. If the letterforms are drawn freehand then a good quality no. 1 or no. 2 pointed sable brush together with india ink and a bridge should be used.

8 Correcting errors

If mistakes have been made during lettering it is not difficult to rectify these using a designer's opaque white paint. Make sure that all pencil lines are erased before attempting to retouch work. Use a plastic eraser over the whole of the design to remove pencil marks and tracing down graphite. It is essential that the ink be perfectly dry before you attempt this process. Impatience has claimed many pieces of artwork. Test a small corner before using the eraser on your work. Check that your brush is clean before applying opaque white paint to errors. If the paint does not cover with one coat, allow the first coat to dry before further application. Overworking the paint while it is still wet results in a softening of the india ink and produces an undesirable gray effect. Retouch the black areas using india ink to give a dense overall consistent cover.

9 Final artwork

When all the letterforms and images are satisfactory, allow the work to dry completely, then cover it with a tracing paper overlay to keep it clean.

This step-by-step procedure is for the production of a piece of artwork for a single color printing job. Where more than one color is required, additional artwork for the different colors should be produced on overlay sheets of acetate which are then taped to the base artwork.

There are a number of drawing film type acetates on the market which accept india ink. Even though the acetate is for a second or third color when printed, the work must still be carried out in black ink or cut from a red blocking film. The film is overlayed onto the acetate and the desired image is cut with a scalpel and the non-image is removed.

Useful tip

If constructing circles and arcs with a technical pen attachment and compass, place a small square of line board over the center for the compass point on the artwork to prevent having to retouch compass points out of the artwork.

Size and layout

When producing a poster or signboard you will apply the skills acquired in studying and practicing letterforms. Your sign may be either a permanent statement or an ephemeral one, but irrespective of its intended use it is important to plan each stage and take care in carrying out your work. You may find it useful to experiment with different letterforms and layouts before finalizing your design. If you need to enlarge the letterforms or if, for example, your design incorporates a logo or other established design, then the step-by-step instructions given below will assist you.

Enlargements
The enlargements can be produced by a photographic process or a photocopier which has an enlarging facility. The latter method is the most economical as black and white photographs can be expensive. There are a number of ways in which brand names and logos can be manually enlarged or reduced.

Enlarging by squaring off
1 Starting at the left hand side of the lettering or logo to be enlarged, draw a line (AB) at the base of the logo in red or blue ink to avoid confusion when plotting the letter.
2 Project vertical lines (AC and BD) at either end of the logo to contain the image.
3 From the bottom left hand corner, project a diagonal line (AE).
4 Divide line AE into equal units and project the last division to the right hand bottom corner of the logo.
5 Project vertical parallel lines from AE to divide the base line (AB).
6 Step off the base line units against the left hand vertical line (AC). Project horizontals until the logo is contained within the grid.
7 Number the units along the base line and up the left hand vertical.
8 Decide on the size of the enlargement you require for the logo.

Task
Enlarging and reducing
Take a logo or brand name and enlarge or reduce it by squaring off.

9 On a sheet of tracing paper, mark in red or blue pen the width you require the logo to be.
10 Subdivide the width into the same number of units as the original.
11 Draw up a grid and number along the base line and left hand vertical.
12 Start plotting the image from the original.

More definition
Definition can be increased by further subdividing the squares already drawn in the original (see the square drawn at the base of the letter K in the illustrations below). This method of enlarging is based on manual digitizing of the original image, therefore the smaller the units used, the more accurate the final drawing.

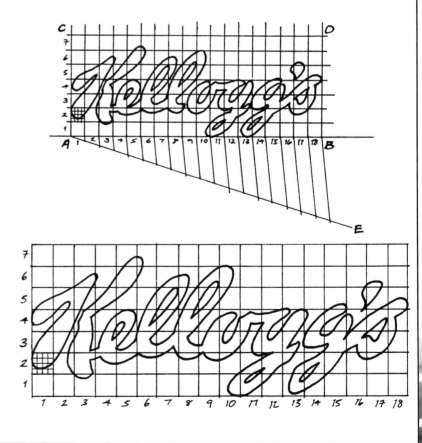

Communication and layout

The layout of all work is important. The information must be conveyed in a simple and easily understood manner. The main aim when producing posters and other notices is to communicate quickly and effectively, capturing the interest of the reader long enough to convey the message.

The choice of layout is very often determined by subject matter. There are, however, five different ways of achieving interest in the arrangement of words. In each of the examples (*right*) a different method of positioning text has been used to achieve the desired effect.

Key words

To arouse the reader's interest, key or "buzz" words are employed. On a sale poster, the word "sale" would be prominent, emphasized by different size, weight, style or color. In its simplest form emphasis can be achieved by merely underlining the key word.

Centered

The line or lines of text in a format which is centered are positioned centrally on an axis to create a symmetrical effect.

Asymmetrical

An asymmetrical layout is one in which the line or lines have no particular relationship with the ground area. They are artistically or aesthetically positioned as opposed to being positioned by set rules.

Justified or squared-up

A justified or squared-up layout is one in which the lines of text are of equal length. Text is aligned vertically at both the left and right hand sides by adjusting the spacing between the letters and words.

Ranged left (or flush left)

A ranged left or flush left layout is one in which all the text has a vertical alignment on the left. The right hand side of the lines of text are unaligned or ragged.

Ranged right (or flush right)

In a layout which is ranged or flush right the lines of copy are vertically aligned on the right hand side, leaving the left hand side appearing ragged or unaligned.

Painting signs 1

Display signs can be found all around us, from the name plate on a house to huge commercial signboards. Although many shop fronts and office signs are produced in permanent materials such as metal or wood there are still opportunities for producing hand painted individual signs. Words may appear on vehicles, freestanding signs and objects. Signs may be used to inform, to advertise, to instruct or to identify.

Producing a sign
Before beginning to apply your lettering the following factors should be considered:

1 How large should the sign be to enable people to read the words?
2 Is it intended to be a permanent statement or a temporary one?
3 Will it be open to the elements, in which case waterproof surfaces and paints are required?
4 Have you resolved the emphasis of the message by first doing some trial sketch designs?

Applying lettering directly
It is a good idea to plan your design carefully and draw a small sketch of the intended arrangement of the elements. Once you have estimated the positions of the lines of copy you may find it useful to mark these onto the surface of your sign. One method commonly used is to set out chalk lines indicating the cap and base line positions.

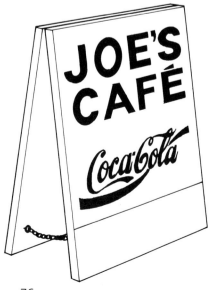

Working rough
In the example shown (*left*) the "A" sign displays "JOE'S CAFÉ" and the Coca-Cola logotype. First a scaled down working drawing is produced to give the approximate sizes of the logotype and the text as illustrated (*above*). This is produced on tracing paper or layout paper in a fine point fiber pen. A sample alphabet is chosen for the wording and the lettering is laid out in two lines. The logo is scaled to fit the required width. The working drawing is scaled around the Coca-Cola logo leaving a margin at either side. The drawing will be one quarter of the final size.

Size
An "A" sign is usually taken from the premises to the forecourt or pavement, so it must be easily managed – not too large and not too heavy to be carried in and out on a daily basis.

Dimensions of a working rough

	Metric units (mm)	Imperial units (inches)
a	900	35.4
b	580	22.8
c	200	7.9
d	536	21.1
e	80	3.1
f	136	5.4
g	42	1.7

Producing a full size working drawing
The logo and text are enlarged to their full width by photocopying or squaring off. They are drawn on tracing paper with a fine fiber pen or 2H pencil. It is not necessary for the entire drawing to be on one sheet of paper. The separate elements can be produced as single items and put into position when tracing down. It is now ready to be transferred to the signboard.

Tracing originals

Tracing out and then tracing down onto the finished surface is by far the most accurate method of producing facsimile work. The draft or original drawing is produced on tracing paper by either tracing directly from an enlarged copy of a specific alphabet or working from photographic enlargements of company brand names and logos.

Mediums used in tracing down

There are two mediums used in transferring a drawing to a signboard, which are as follows:
1 A soft 2B lead pencil.
2 Colored or white chalk (depending on the color of the surface the image is to be transferred to).

Pencil transfer

To transfer with pencil, turn the working drawing face down on a flat surface. Take the 2B pencil and rub over the back of the drawn lines (*right*). The pencil must be worked into the paper by using a cloth or paper tissue, with any excess graphite being shaken from the tracing sheet.

Chalk transfer

When using chalk, the same procedure as that used for pencil transfer is adopted but the chalk is worked over the whole of the image area before being worked into the paper.

Useful tip

Avoid using red or green chalk for transferring to white surfaces as both colors tend to be difficult to remove.

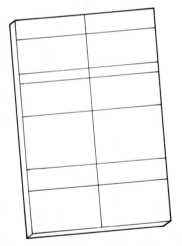

Preparing the board for tracing down

Refer back to your scale drawing for the measurements relating to the positioning of the elements. Begin by drawing positioning lines on the board. Draw the base lines for the text in HB pencil and indicate the base line for the logo together with the line showing the ending of the sash of color at the base of the board. A center line must run from the head to the foot of the board (*above*). The full size drawing must have a center line added at the top and base of each image to assist in correct positioning.

Tracing down (*above*)

1 Position the wording "JOE'S CAFÉ" onto the appropriate base lines and secure with masking tape, making sure that the center lines correspond.
2 Position the logotype on its base and center lines and secure with tape.
3 Using a sharp 4H pencil, trace over the images to transfer the graphite onto the signboard (*above right*).
4 When the whole of the image has been traced, release the masking tape at the bottom of the sheet. Lift the sheet using the top tape as a hinge, and check that the image has been transferred successfully.

5 If any areas are missing replace the sheet and retrace the missing area. Check again before removing the tracing sheet

Task

Tracing down

Practice tracing off letters and some easy logos that you may find in advertisements in magazines. Rub over the back with pencil and trace down onto paper to begin with.

©DIAGRAM

Painting signs 2

Once the letterforms have been carefully transferred down to the surface, they can then be painted in. It is preferable to develop good steady hand control techniques as correction and alterations spoil the appearance of the finished sign. Work slowly and learn the order of painting in horizontals, verticals and curves so that at all times you are in control of the brush.

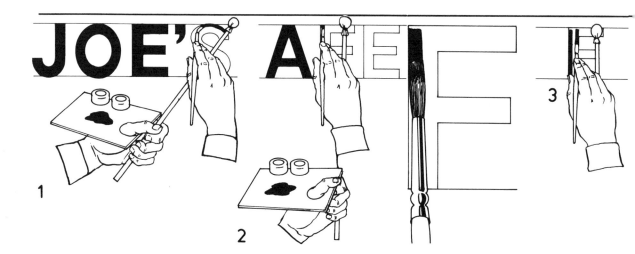

1 Method
Make sure that the brush is clean. New brushes should be cleaned in white spirit to remove the manufacturer's coating. Load the brush with paint from the paint holder or tin. Stroke the brush across the edge of the holder to remove excess paint. Hold the mahl stick and palette as illustrated (*above*).

2 Painting vertical lines: left hand strokes
Start painting at the top of the letterform just below the capital line. First concentrate on the left hand edge of the letter – the line made to the right of the brush should be tidied up later. Using a deliberate movement paint the vertical stroke; this should be done with reasonable speed because cleaner lines are formed by continuous, quick movements. Finish the stroke short of the base line. Look only at the left side of the brush and not the line that is being painted. If you concentrate on the direction of the movement of the brush the line that you produce should be straight. The paint is deposited by the brush at about ¼" (6 mm) from the tip, which is its widest point when loaded with pigment.

3 Right hand strokes
To paint the right side of a vertical stroke concentrate on the right side of the brush. Finish the vertical line by filling in the area between the strokes (*above*).

Useful tip
During painting, the brush will become tired and the spring in the hair will be lost. This is a result of paint drying out or building up on the brush. Dip it in a little white spirit and dry on a cloth before reloading with paint.

Useful tip
Charge your brush with paint frequently, remembering to remove any excess. The bristles should be covered in paint up to the ferrule (the metal part).

Painting in letterforms in sign-writing

Once the image has been transferred to the board the letters require painting in.

Tools and materials
You will require the following additional equipment for sign-writing:
1 A mahl stick for supporting your writing hand.
2 A good chisel-ended writing brush, no. 4 size.
3 A palette and clip-on holder for paint and white spirit.

Your work area
Your work station area will require some minor alterations before you begin signwriting. The board should rest on an easel. It is possible to make an easel from two lengths of timber, pre-drilled to give various positions for the board to rest at (*right*). It is important to position the board at a height that enables you to work comfortably. Stooping or stretching is very tiring and invariably affects the quality of the work produced.

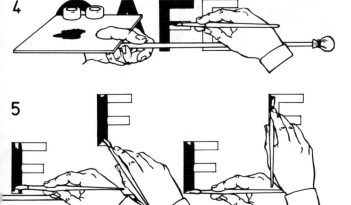

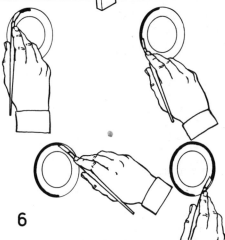

4 Painting in cross strokes
The brush must have a good flat chisel shape to get into the corners. Look above the stroke being lettered as you work (*above*). Paint in the cross strokes at the capital line. Move down to produce the lower line of the stroke, looking below the brush to check on the progress of the painting. Finally finish the end of the cross bar with a short vertical stroke after first sharpening up the corners.

5 Finishing main strokes
The cross stroke at the base line is lettered in the same manner as painting in the cross strokes. Keep a good chisel edge on the brush when sharpening up corners. Look underneath the brush to follow the progress of the line.

6 Round letterforms
The method for painting in round letterforms is, in principle, the same as that for straight letterforms, whereby the line of vision is directed on that side of the brush which forms the outer edge of the letterform. It is advisable to start at the center of a form and work out and downwards on the upper quarters and down and inwards on the lower quarters, with the inner portion being worked in the same way. Once you have become proficient at quarters of letterforms semicircles may be attempted.

7 Masking capital and base lines
The process of sharpening up corners is technically good and gives a neat finish. The beginner may wish to mask straight letters at the cap and base lines; this makes it easier to form letters but does not give such a crisp

result. Masking tape is placed along the cap and base lines where straight sided letters appear, which makes it unnecessary to paint cross strokes at these lines (*below*). The tape is removed just after the letters have been painted to prevent a skin forming between the tape and letterform.

©DIAGRAM

Painting signs 3

In signwriting today, accuracy of style is very important. The main disadvantage of producing letterforms freehand is that the writer may produce inconsistent letterforms and stroke widths. The writer may also be tempted to create a new style rather than copy an existing one.

Free written letterforms
An accomplished writer may need only a capital and base line to work within. The words are lightly chalked between chalk lines to give an approximate letter and word spacing and the length the text will take. The lettering is then signwritten using a mahl stick to steady the hand.

Chalk lines
To produce the chalk cap and base lines, chalk is rubbed into the strands of a length of string. The positions of the lines are marked in chalk at both ends of the sign surface and the string is stretched between the markers. The line is held firmly at one end while the other end is held in place by one finger. The chalked string is then snapped taut against the surface so that it deposits chalk dust, forming a line on the surface to be lettered.

Task
Assembling your tools and materials
Practice holding the brush and mahl stick before you commence painting so that you can find the best position to work in and adjust your easel accordingly.
Collect together your paints, cleaner and cloths so that you can proceed uninterrupted.

Task
Signwriting
If possible, visit a commercial art studio and ask if you can watch an experienced lettering artist at work. It is surprising how easy it appears but how much care and experience go into simple lettering tasks.

Task
Photograph your work
If your board is to be given away or sold, it is a good idea to photograph it first for future reference. Start an album with photographs of your own work with completion dates and any points you think you will find useful later on.

Task
Take pride in your work
Make sure that all the work you produce during your studies is carefully stored in a portfolio or desk drawer. If you do not admire and have pride in your own skills, then it is unlikely that others will see the merit of your efforts. Never be over critical of your work. Each stage is a stepping stone to producing accomplished work.

RESTAURANT & I

©DIAGRAM